IMAGES
of America

UNITED STATES LIFE-SAVING
SERVICE IN MICHIGAN

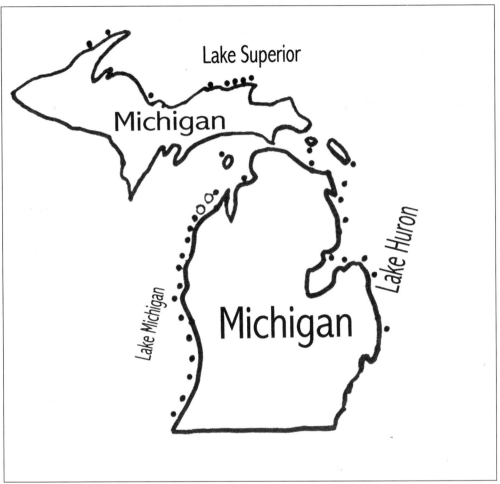

U.S. LIFE-SAVING SERVICE STATIONS, MICHIGAN. Brought to the Great Lakes by the Federal Government in the 1870s, U.S. Life-Saving stations and early Coast Guard stations numbered in the 30s by 1920. This map shows the locations of many of those U.S. Life-Saving Service and U.S. Coast Guard installations.

IMAGES
of America

UNITED STATES LIFE-SAVING
SERVICE IN MICHIGAN

William Peterson

ARCADIA

Published by Arcadia Publishing,
an imprint of Tempus Publishing, Inc.
3047 N. Lincoln Ave., Suite 410
Chicago, IL 60657

Printed in Great Britain.

Library of Congress Catalog Card Number: 00-106464

For all general information contact Arcadia Publishing at:
Telephone 843-853-2070
Fax 843-853-0044
E-Mail sales@arcadiapublishing.com

For customer service and orders:
Toll-Free 1-888-313-2665

Visit us on the internet at http://www.arcadiapublishing.com

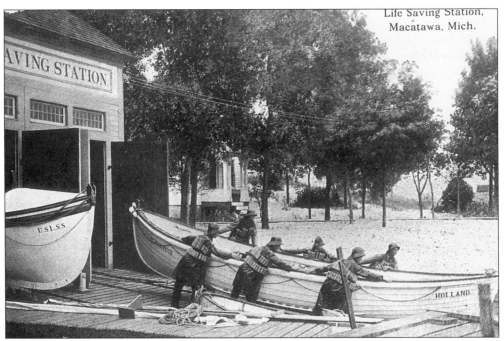

U.S. LIFE-SAVING SERVICE, HOLLAND, MICHIGAN. From 1876, the U.S. Life-Saving Service made the waters of the Great Lakes safer for mariners and passengers through training, dedication, and constant preparedness. Eventually, the Life-Saving Service operated over 60 stations on the lakes. Today that job is held by the United States Coast Guard. (Courtesy Michigan Maritime Museum.)

CONTENTS

ACKNOWLEDGEMENTS

Generous credit must be given to the Michigan Maritime Museum, Sleeping Bear Dunes National Lakeshore, The Michigan Historical Center and Archives, and the Alcona Historical Society for their generous policies regarding the use and reproduction of images in their collections. Without them, this book would not be possible. A special thanks goes to John Boufford and Cheryl Peterson at the Alcona County Review for all their help in this project. I would also like to thank Ralph Shanks, my wonderful wife Susan, and step-daughter Emilie Riggs for their help and suggestions. Enough credit cannot be given to Ralph Shanks and Wick York and their book, *The U.S. Life-Saving Service: Heroes, Rescues, and Architecture of the Early Coast Guard,* as the architectural information in this book was compiled using their publication. I would like to thank Fred Stonehouse for his suggestions and book, *Wreck Ashore: The United States Life-Saving Service on the Great Lakes,* which was another valuable resource used in this project.

INTRODUCTION

On a map of the United States, the Great Lakes are the major geographical feature of the Midwest. They have shaped the development of our country throughout history. Our efforts to use them to our advantage for the transportation of people and material are endless. Unfortunately, the Lakes can be as dangerous as they are useful and beautiful. Storms, collisions, and unsafe sailing practices all contributed to the dangers faced on the Lakes by mariners. In fact, shipwrecks were a major concern throughout the history of the United States. We lit signal fires to warn vessels away from hazards, and later we built lighthouses as permanent aids to navigation. Still, maritime disasters continued to plague the nation, taking lives, wrecking ships, and destroying cargoes.

Sailing activity on the Great Lakes virtually exploded between 1850 and 1876. In 1854, miners discovered high-grade iron ore in Michigan's Upper Peninsula, while the lumber trade boomed throughout the state. In 1855, the locks at Sault Ste. Marie opened, allowing easy access between Lake Superior and Lakes Huron and Michigan. The first year, 106,296 tons of cargo locked through, and by the Civil War the lock handled in excess of 400,000 tons. Increased vessel traffic meant an increase in accidents and disasters. Between 1864 and 1874, 4,527 vessels were lost on the Lakes, resulting in 1,341 deaths and more than $27 million dollars in damages.

In August of 1848, Congressman William A. Newell urged the passing of a federal law to provide $10,000 for the necessary equipment, such as surfboats and line-throwing devices for the New Jersey coast. In 1871, the Federal Government further attempted to address this problem with the creation of the United States Life-Saving Service (USLSS), which operated under the auspices of the U.S. Revenue Cutter Service (USRCS). In 1873, Congressman Eugene Hale, from Maine, introduced legislation asking for funds to further expand the Life-Saving Service along the Atlantic coast. At the same time, Sumner I. Kimball (1834–1923), head of the U.S. Revenue Cutter Service, used this as an opportunity to expand the USLSS to the Great Lakes. When the legislation passed in Congress on June 20, 1874, the USLSS entered Great Lakes history. Sumner Kimball became the general superintendent of the USLSS, and held the position from 1878 until his retirement in 1915. After 1915, the USLSS merged with

the USRCS and became the modern entity we know as the United States Coast Guard (USCG). The following photos document the activities and efforts of the USLSS and early Coast Guard in Michigan.

The Life-Saving Service operated along the ocean coasts and the Great Lakes in different levels. In Michigan, the majority of USLSS stations were "first-class," meaning they contained a full complement of equipment and buildings to accommodate and house a crew of up to eight. The head of each station was the keeper, followed by surfmen who ranked one through seven or eight, eight being the lowest in seniority. Essentially, the function of the USLSS was the constant patrolling of the beaches. In this way they could warn off vessels running too close to shore and could watch for disasters. The crews were also responsible for boat rescues using their surfboats and lifeboats. Most stations had both types of boats. The surfboats were lighter and somewhat smaller than the lifeboats. In the event of an emergency, the USLSS crews launched their boats to take passengers and sailors off stricken ships.

At times, the conditions on the Lakes were too rough for even the life-savers to get boats launched. During these times, the crews used a piece of equipment called the beach apparatus for rescues. This method of rescue involved a small cannon called a Lyle gun, which fired a line and weight, or messenger, over the mast of the vessel. This line was used by the stranded crew to pull a hawser aboard. Through this system of anchors, lines, and pulleys, the USLSS could then bring crew members to shore in either the breeches buoy or the life car. The breeches buoy is an oversized pair of canvas pants sewn over a life ring, and the life car is a small, waterproof, metal capsule that could hold up to three people. The crews also practiced the "resuscitation of the apparently drowned," the historical equivalent of mouth-to-mouth respiration. It involved inflating and deflating the lungs by expanding the victim's rib cage. Although rather primitive by today's standards, it worked quite well. The crews practiced all through the week for each of these activities. Once a crewman learned his job, he then learned the job of the other surfmen. Teamwork was the order of the day and the key to the success of the Life-Saving Service.

The first USLSS stations were built in Michigan in 1875–76, with many still standing. All told, Michigan had 38 USLSS and early USCG facilities. Today, modern technology allows the USCG to maintain its coverage with fewer stations. Architecturally speaking, Michigan has eleven types of stations drawn by five USLSS architects. Although the designs were the same, the crews modified their stations over the years. The result is small differences even among "identical" stations. Lake Michigan received 17 stations, Lake Huron, 11, and Lake Superior, 10. Regrettably, I could not include photos for each of the stations, and coverage for Lakes Huron and Superior is lacking. Nonetheless, these photos tell the story of these brave men and provide us with glimpses into their lives. Their work was monotonous, often dangerous, and done for relatively low pay. However, it was also exiting and romantic. I hope the following photos convey that, as well as instilling in viewers a sense of pride in our actions and maritime traditions. The USLSS existed solely to help others out of dangerous situations, and many crews lost members to the waves while saving thousands from that very fate. Yet they persevered, and the same traditions and ethics that motivated them exist today within the ranks of the Coast Guard.

One

LAKE MICHIGAN

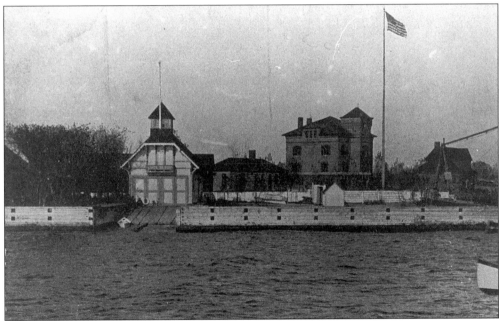

U.S. LIFE-SAVING STATION, ST. JOSEPH, MICHIGAN. The St. Joseph Station is an 1875 type with a clipped gable designed by Francis W. Chandler. The 1875 design featured exterior braces all around the station and a lookout and walkway on top of the boathouse. The stations were about 20 feet wide and 45 feet long. This photo clearly shows the clipped gable below the lookout. The small powered launch in the foreground was a common mode of transportation in Lake towns during this era. (Courtesy Michigan Maritime Museum.)

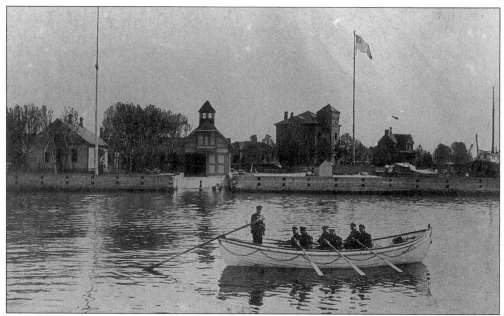

U.S. LIFE-SAVING STATION AND CREW, ST. JOSEPH, MICHIGAN. This is the St. Joseph Life-Saving crew during rowing practice with their surfboat. The keeper is standing in the stern of the boat with the steering oar. The keeper was the eyes of the crew from this sternpost during rescues, and from here he guided the crew alongside stranded vessels in rough weather. (Courtesy Michigan Maritime Museum.)

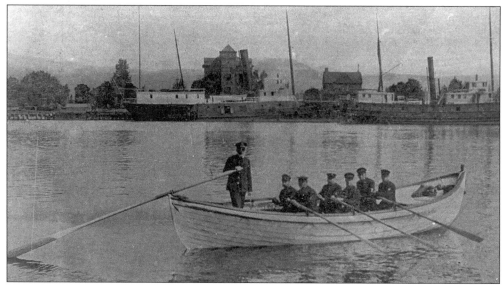

U.S. LIFE-SAVING STATION CREW, ST. JOSEPH, MICHIGAN. This is a postcard of the St. Joseph crew during boat practice dated September 2, 1909. The numeral "7" on the arm of the surfman second from right and the "1" on the arm of the surfman third from left indicates their rank in the Service, with "1" being the closest in rank to the keeper. Experience with boats, skill, and seniority determined rank within the USLSS, and in the event that the keeper was away from the station, the number-one surfman was left in charge.(Courtesy Michigan Maritime Museum.)

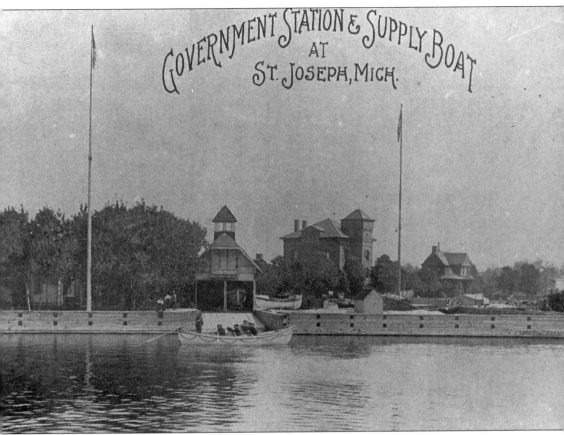

U.S. Life-Saving Station and Crew, St. Joseph, Michigan. Rowing practice took up a great deal of time for the crews. Pictured here is practice with the surfboat. Notice the lifeboat on the dock next to the station, behind the crew. Also notice another larger lifeboat still in the carriage inside the station ready for launching. Lifeboats were designed in Europe and first used in the United States along the Atlantic seaboard. In contrast, the surfboat is uniquely American in origin. (Courtesy Michigan Maritime Museum.)

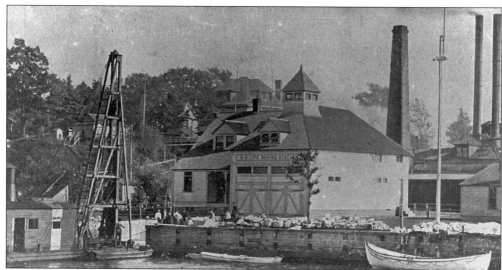

U.S. Life-Saving Station, South Haven, Michigan. Now the site of the Michigan Maritime Museum in South Haven, this station is a Bibb #3 type, built in 1887 on plans drawn by USLSS architect Albert B. Bibb. This station featured a gabled station house and a semi-detached boathouse with a hip roof. The house paralleled the lakeshore, while the boathouse obviously faced it. Always a busy port on Lake Michigan, there is dredging activity taking place in the harbor around the station when this 1919 postcard was shot. A strange feature of the Bibb #3 design was the enclosed lookout tower on the boathouse and a rooftop walkway on the station house. (Courtesy Michigan Maritime Museum.)

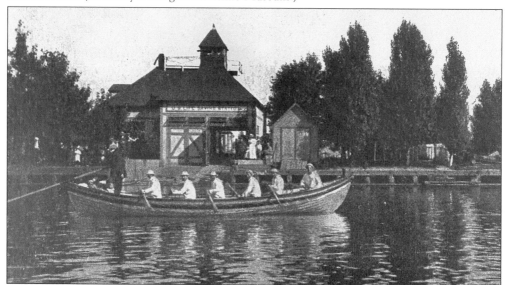

U.S. Life-Saving Station and Crew, South Haven, Michigan. The uniforms used by the USLSS varied during the years. Pictured here is the crew in their "summer white" uniforms and keeper in his dark blue dress uniform. In 1889, dress uniforms were standardized in dark blue with few changes until after the USCG formed in 1915. Prior to 1889, the crews were allowed considerable leeway in their choice of uniforms. Notice the crowd of women and children on the dock in front of the station watching the men practice. (Courtesy Michigan Maritime Museum.)

U.S. LIFE-SAVING CREW, SOUTH HAVEN, MICHIGAN. This crew is practicing the capsizing and righting of their surfboat in their bathing suits. This drill occurred on the Lakes from the time the shipping season opened each spring. Much of the time, the water was barely above freezing. This crew is in the mouth of the Black River in South Haven. (Courtesy Michigan Maritime Museum.)

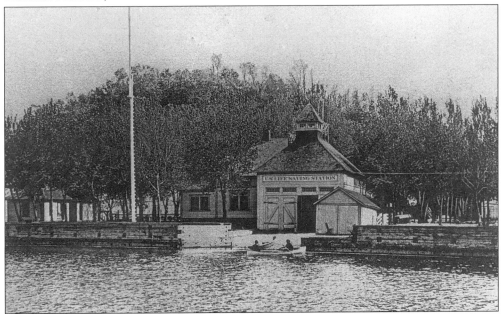

U.S. LIFE-SAVING STATION, HOLLAND, MICHIGAN. Also known early on as the Lake Macatawa Station, the Holland Station is a Bibb #3 type, built in 1885–86. Even though the stations were built on the same plans, note the difference in the way the catwalk on top of the roof to the lookout is structured between the Holland and the South Haven Stations. The Service allowed considerable modifications of stations as deemed necessary or desirable by the keepers or crew. (Courtesy Michigan Maritime Museum.)

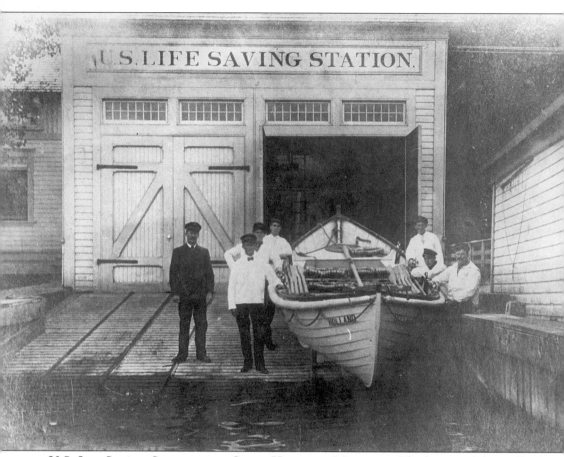

U.S. LIFE-SAVING STATION AND CREW, HOLLAND, MICHIGAN. The keeper of the Holland Station is standing to the left of his crew in the dark uniform. The crew is posed with their surfboat ready for launching. All the gear in the boat had a specified place. In the boathouse behind the men is a ladder leading up into the rafters. On the seats of the lifeboat are the cork life jackets worn by the USLSS. Other emergency gear carried in the boat included hatchets for cutting entangling rigging, extra lines, and heaving sticks. Heaving sticks are heavy wooden clubs used to throw lines from one ship to another. (Courtesy Michigan Maritime Museum.)

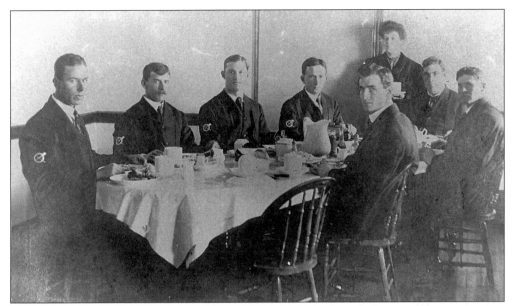

U.S. Life-Saving Station and Crew, Michigan. A sharp-looking crew is pictured at suppertime. This undated postcard is addressed Macatawa and may be the Holland crew. The woman is probably the keeper's wife. The keeper's wife was in charge of feeding the on-duty crews at many stations around the Lakes, in exchange for $16 per month from the surfmen for the purchase of supplies. Women played an important role in the Service. The keeper's wife not only fed the crews, but also nursed rescue victims while they recuperated at the stations. Surfmen's wives lit and tended bonfires on the beach during rescues and led prayers for the safe return of their husbands and other mariners. (Courtesy Michigan Maritime Museum.)

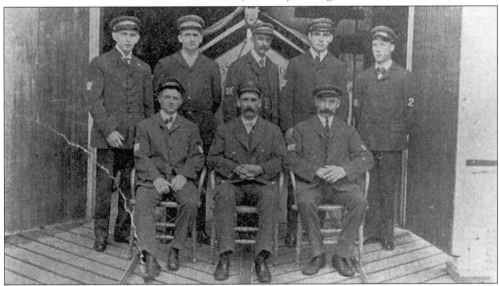

U.S. Life-Saving Station and Crew. This crew shot, taken *c.* 1906, shows what is believed to be the Holland crew. Standing from left to right are: Harry VandenBerg, Robert Vos, Francis Cady, Robert C. Smith, and the number two surfman, John E. Roberts. Sitting from left to right are: William Woldring, Captain or Keeper C.D. Pool, and the number one surfman, Oscar Johnson. (Courtesy Michigan Maritime Museum.)

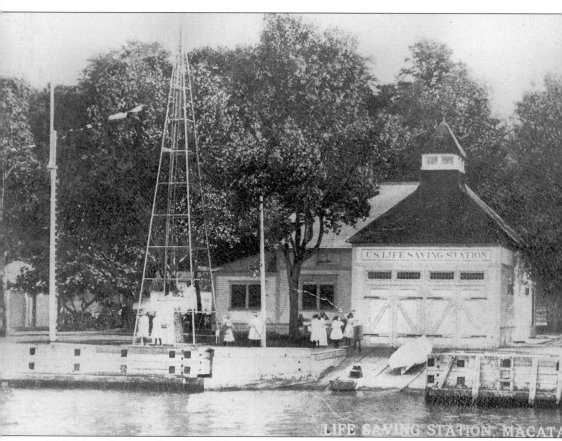

U.S. Life-Saving Station, Holland, Michigan. Sometimes the crews changed the outward appearance of the stations. This photo, taken about 1914, shows that the catwalk on top of the station has been removed and a signal flag tower has been added to the front of the station. Stations were often in picturesque locations. Even though there appears to be no official activity taking place, the grounds of the station are crowded with children. In fact there were almost always children at the stations, as the families of the surfmen lived nearby. As the focal point for these small communities, the USLSS always gave a warm welcome to curious visitors. (Courtesy Michigan Maritime Museum.)

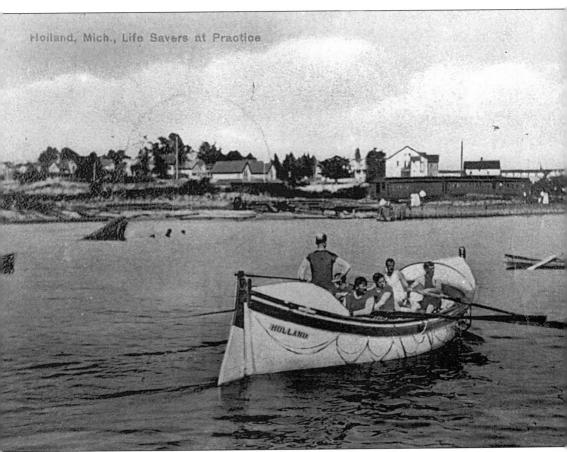

Holland, Mich., Life Savers at Practice

U.S. Life-Saving Crew, Holland, Michigan. Here is an action shot of the Holland crew practicing in the English lifeboat, c. 1908. This boat was self-bailing as well as self-righting. The English lifeboat is larger than the surfboat and is characterized by its flotation compartments located in the bow and stern. The crew is wearing their bathing suits for this practice. (Courtesy Michigan Maritime Museum.)

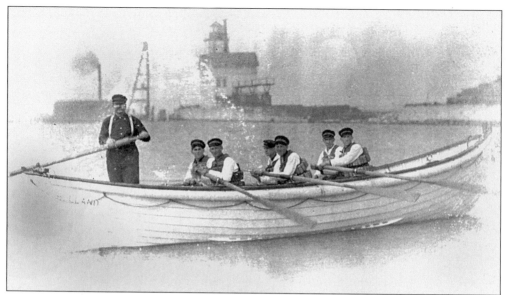

U.S. LIFE-SAVING CREW, HOLLAND, MICHIGAN. This is an excellent shot of the Holland crew in their surfboat. The keeper is standing in the stern with the steering oar, and the crew has on the standard cork life jackets. Notice that there is an empty set of oar locks to the right of the last crewman in the bow of the boat. The Holland light is in the background. (Courtesy Michigan Maritime Museum.)

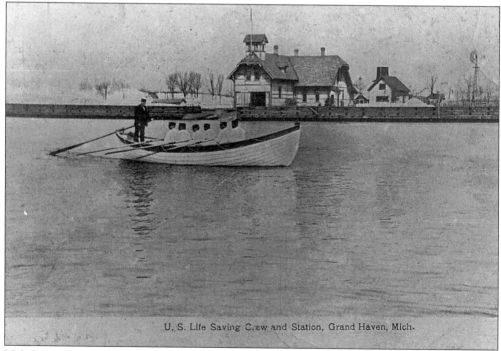

U. S. Life Saving Crew and Station, Grand Haven, Mich.

U.S. LIFE-SAVING STATION AND CREW, GRAND HAVEN, MICHIGAN. Built in 1875–76, this is an 1875 type station with a clipped gable designed by architect Francis W. Chandler. This crew is at practice with the surfboat, c. 1900. Access to the lookout tower on this station is from the interior, and there is no exterior catwalk visible. (Courtesy Michigan Maritime Museum.)

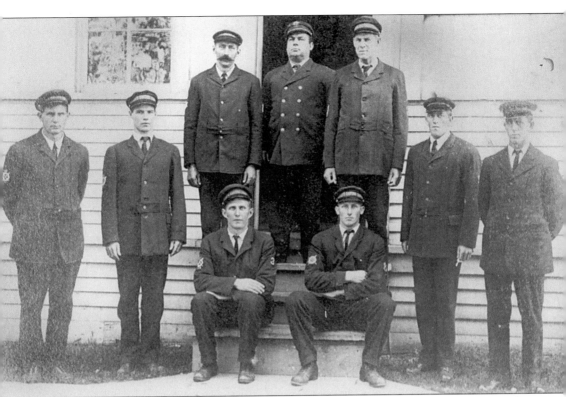

U.S. Life-Saving Crew, Grand Haven, Michigan. The keeper is standing in the center of this crew. Charged with the daily operations of the station, the keeper had to be literate with business knowledge and experience. On top of that, he had to be an expert in the skills of life-saving, in excellent physical shape, and between the ages of 21 and 45. Pictured here is the eight-man Grand Haven crew, with the keeper in the back row center. The names of the crew pictured are: ? Peterson, ? Will, ? Jansen, ? Fisher, ? Vandenberg, ? Bottye (?), ? Wascow, and ? Olsen. Surfmen three and eight are seated in front. (Courtesy Michigan Maritime Museum.)

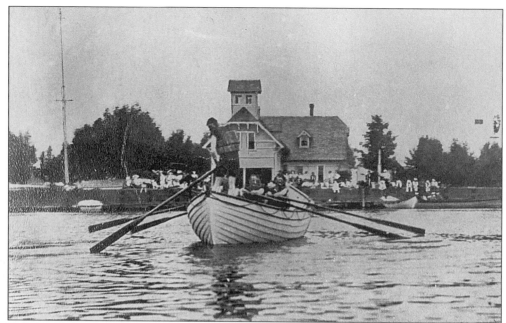

U.S. LIFE-SAVING STATION AND CREW, GRAND HAVEN, MICHIGAN. On nice days, practice with the surfboat almost always drew large crowds. This photo shows the Grand Haven crew at practice, c. 1908–09. The station grounds are crowded with spectators, and the life car is floating at the base of the pole on the left of the picture. This crew is rather small, operating with only four oars in the water. (Courtesy Michigan Maritime Museum.)

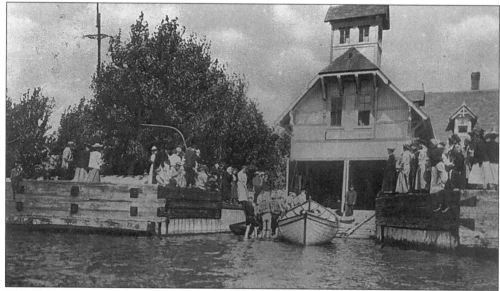

U.S. LIFE-SAVING STATION AND CREW, GRAND HAVEN, MICHIGAN. This photo, taken c. 1910, shows the Grand Haven USLSS crew getting ready for boat practice. Once again the activities of the crew have attracted a large group of spectators. Here the keeper is shown standing in his uniform between the boathouse doors. Even with constant practice, the life of a surfman was hazardous. On the Great Lakes, 40 USLSS surfmen were lost in the line of duty between 1876 and 1901. (Courtesy Michigan Maritime Museum.)

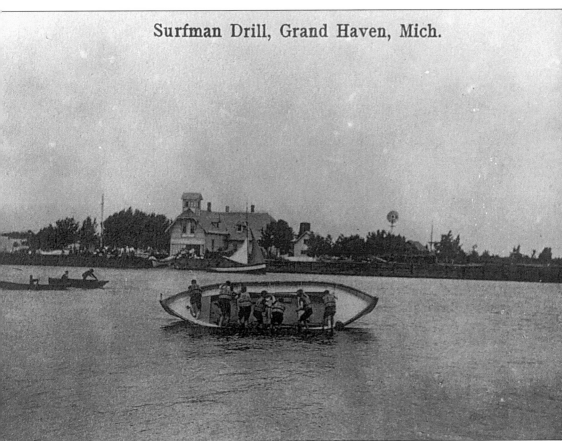

U.S. LIFE-SAVING STATION AND CREW, GRAND HAVEN, MICHIGAN. This photo shows the capsizing drill. The crew pulled the boat over, keeping clear of the gunwales as it capsized. The keeper pictured in the far left scrambled around the stern of the boat, often not getting completely wet. Notice again the large crowds gathered around the station watching the drill. (Courtesy Michigan Maritime Museum.)

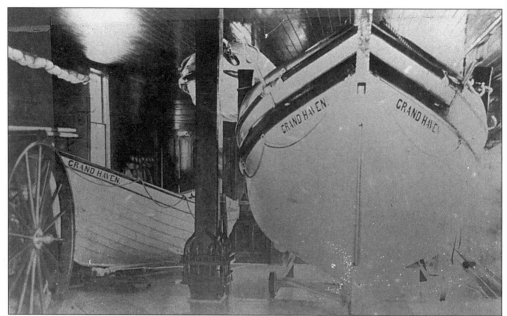

U.S. Life-Saving Station, Grand Haven, Michigan. This shot shows the interior of the boathouse at the Grand Haven Station. The surfboat is on the left and the lifeboat on the right, with the life car hanging from the ceiling in between the two boats. Each and every piece of equipment had its place, and the crews made sure each was put in the proper place. No time was wasted looking for equipment when needed for a rescue. (Courtesy Michigan Maritime Museum.)

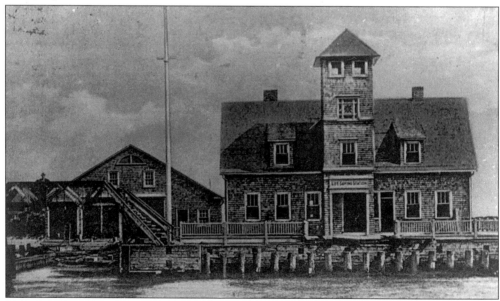

U.S. Life-Saving Station, Muskegon, Michigan. This photo shows the second station built in Muskegon. Built in 1904–05, this station is a Racine type, designed by the architect Victor Mendelheff. Built only on Lake Michigan, this is a rather rare style of station. The first Muskegon station (not pictured) was an 1879 type, built in 1879. This photo is dated 1909. (Courtesy Michigan Maritime Museum.)

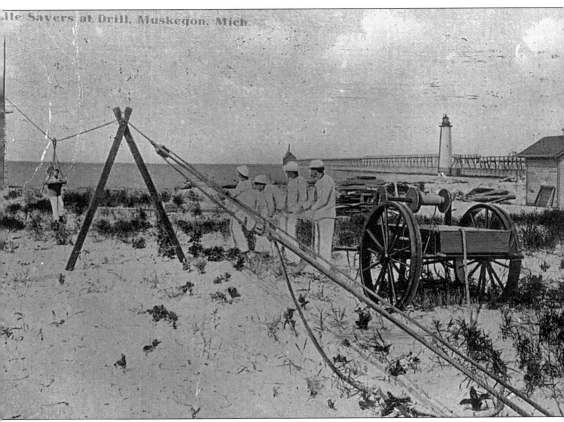

U.S. LIFE-SAVING CREW, MUSKEGON, MICHIGAN. This shot from 1909 shows the Muskegon crew practicing with the beach apparatus and the breeches buoy. The beach cart is the two-wheeled cart shown to the right and held all the equipment needed for this type of rescue. The crew has a line established between the wreck pole, which simulated the mast of a wrecked vessel in the distance, and the "crotch" on the shore. The keeper is on the far left and a crewman is riding the buoy. (Courtesy Michigan Maritime Museum.)

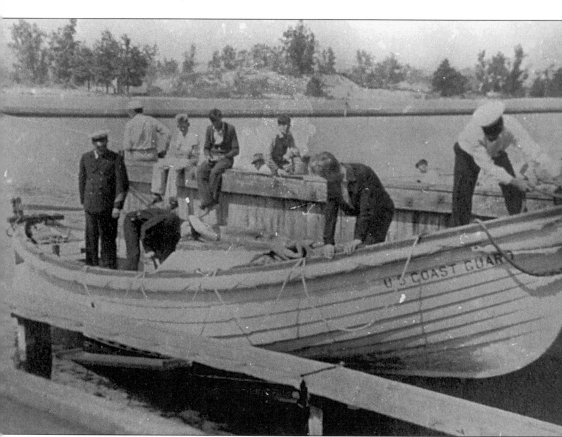

U.S. Coast Guard, Muskegon, Michigan. This is an early shot of the USCG working on the surfboat at Muskegon. After 1915, the Life-Saving Service merged with the U.S. Revenue Cutter Service, becoming the Coast Guard. Surfboats were motorized as the technology became available. Motors meant that crews increased the range of their coverage while getting to wrecks more quickly. Once on the scene they were much fresher, not having been worn out by the difficulty of a long, hard row. (Courtesy National Park Service.)

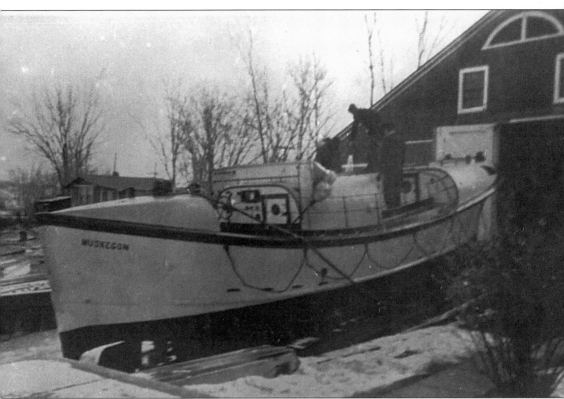

U.S. COAST GUARD, MUSKEGON, MICHIGAN. This winter shot of the Muskegon crew working on their 36-foot motor lifeboat illustrates the advances in technology from the earlier days of the USLSS. This boat is capable of self-bailing and self-righting. The boathouse in the background is recognizable as the 1904–05 Racine type by the three windows above the boat doors. (Courtesy National Park Service.)

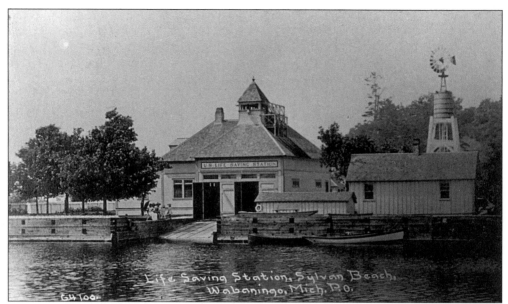

U.S. LIFE-SAVING SERVICE, WHITE RIVER, MICHIGAN. Built in 1886–87 in Whitehall, Michigan, at the mouth of the White River, it was also known as Sylvan Beach. This station is another example of a Bibb #3 type, designed by Albert Bibb. This 1913 photo clearly shows a boathouse and windmill on the right of the photo. (Courtesy Michigan Historical Center.)

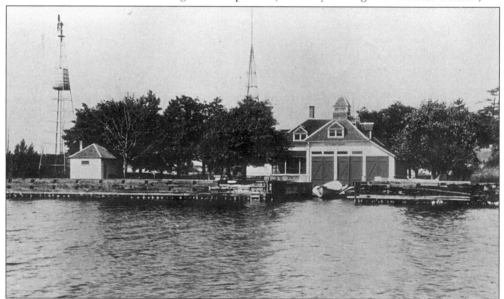

U.S. LIFE-SAVING SERVICE, WHITE RIVER, MICHIGAN. By the time this photo was taken of the White River Station, the boathouse was gone, the windmill moved, and signal tower added. Other changes included the addition of dormer windows on the roof of the station. Crews were given considerable flexibility to modify the stations as long as they received the proper authorization from the district superintendent. Signal towers were for the display of the international signal flag codes, which consisted of 26 different colored flags, one for each letter of the alphabet. The flags could be used in various combinations to communicate phrases. This allowed crews to communicate over long distances with vessels.

U.S. LIFE-SAVING SERVICE, WHITE RIVER, MICHIGAN. Shown here in front of the lighthouse is the White River crew practicing with the lifeboat. In this unusual photo, the crew is invisible behind the boat as it capsizes. The three holes in the bottom of the boat are scuppers for the self-bailing action. Often located in close proximity with lighthouses, the two organizations worked closely to keep the Lakes safe. (Courtesy Michigan Maritime Museum.)

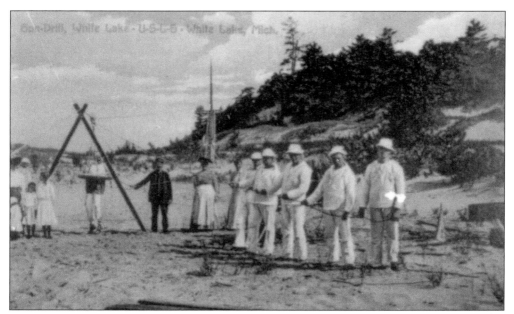

U.S. LIFE-SAVING SERVICE, WHITE RIVER, MICHIGAN. This is the breeches buoy drill at the White River Station. Women and children are gathered around the crew as they drill. The boom of the Lyle gun, the line whizzing out behind the messenger, and the thrill of the breeches buoy landing on shore pleased young and old spectators alike. (Courtesy Michigan Maritime Museum.)

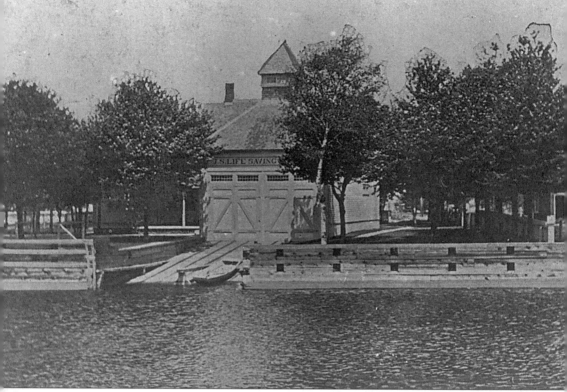

U.S. LIFE-SAVING SERVICE, PENTWATER, MICHIGAN. Characterized by its shapely roof lines and lookout tower, the Pentwater USLSS Station is another Bibb #3 type, built in 1886–87. This shot, taken in the summer of 1916, shows quiet times at the station. Surfmen were permitted to leave the station during daylight hours and good weather at the discretion of the keeper. If weather turned bad, regulations stated that they must return immediately to the station for duty. (Courtesy Michigan Maritime Museum.)

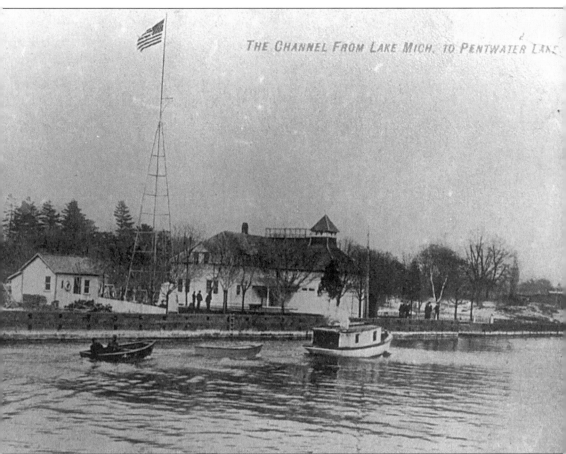

U.S. LIFE-SAVING SERVICE, PENTWATER, MICHIGAN. This winter shot of the Pentwater USLSS Station clearly shows the signal flag tower, the railing on the walkway behind the lookout on the roof of the station, and the smaller buildings behind the station. Oftentimes these cottages were the homes of surfmen with families. Unmarried crewmen could bunk in the station proper above the boathouse. Although the weather looks chilly in this *c.* 1908 shot, there is plenty of activity at the station. (Courtesy Michigan Maritime Museum.)

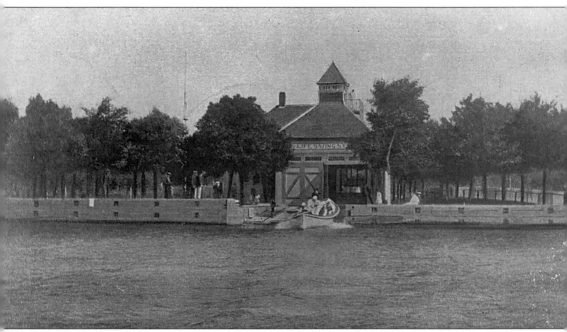

U.S. LIFE-SAVING SERVICE, PENTWATER, MICHIGAN. This undated postcard is an action shot showing the crew launching the surfboat. Once again there are spectators watching the men work. Also shown in this view is the crewman on lookout, standing on the catwalk just to the right of the lookout tower. (Courtesy Michigan Maritime Museum.)

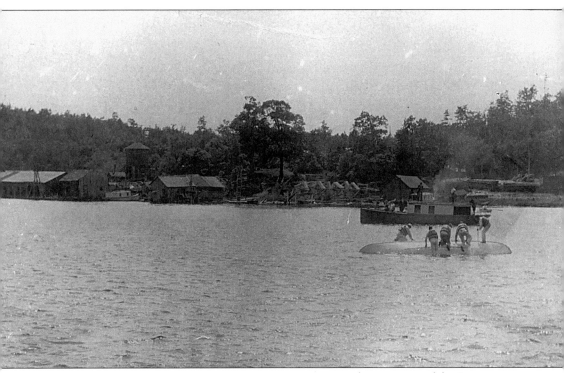

U.S. LIFE-SAVING SERVICE, PENTWATER, MICHIGAN. Here are the crewmen of the Pentwater USLSS Station hard at work on August 28, 1910. They have just capsized their boat and are getting ready to grab the lines and pull it back upright. This time they have an audience on both the boat in the background and on the shore to the far right. Notice the fish nets drying on the shore just ahead of the second boat of onlookers. (Courtesy Michigan Maritime Museum.)

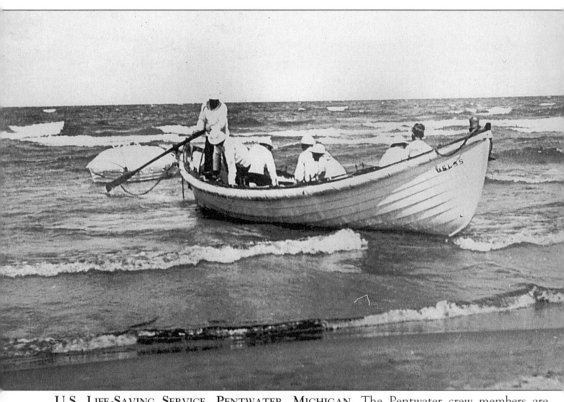

U.S. LIFE-SAVING SERVICE, PENTWATER, MICHIGAN. The Pentwater crew members are drilling on the shore of Lake Michigan. The life car is in the surf just behind the surfboat. Used as an alternative to the breeches buoy, the life car helped in many rescue situations. (Courtesy Michigan Maritime Museum.)

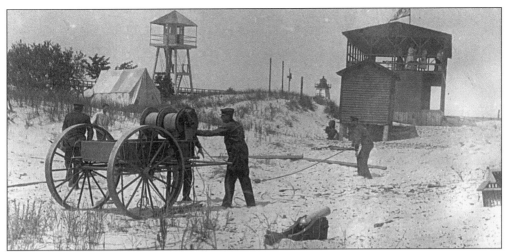

U.S. LIFE-SAVING SERVICE, PENTWATER, MICHIGAN. The beach apparatus drill was always a crowd pleaser. This photo clearly shows the Lyle gun in the lower center of the photo. This small brass cannon was capable of shooting a messenger with a line attached to vessels stranded up to 400 yards off shore. There are several women present in the observation building on the right of the photo, and the Pentwater harbor light can be seen behind the dune just to the left of the women on the deck. (Courtesy Michigan Maritime Museum.)

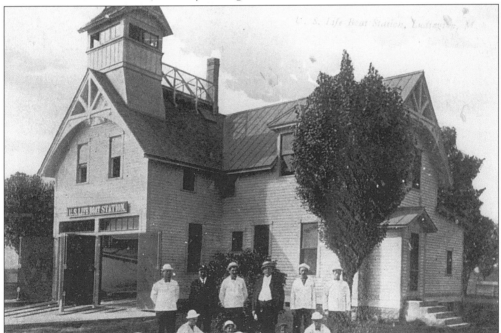

U.S. LIFE-SAVING SERVICE STATION, LUDINGTON, MICHIGAN. Built in 1879, the Ludington Station is an 1879 architectural type designed by J. Lake Parkinson. The gables of this design feature stick-style bracing. The portion of this station in the right of the photo was an addition, as was the lookout tower. The first station built at Muskegon (not pictured) was of this design. This 1912 postcard shows the crew outside the station with some guests. The walkway behind the lookout tower was originally used as a lookout platform. (Courtesy Michigan Maritime Museum.)

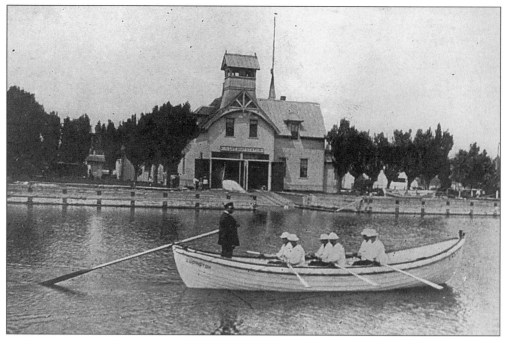

U.S. LIFE-SAVING SERVICE STATION AND CREW, LUDINGTON, MICHIGAN. The Ludington crew is practicing in calm weather wearing their "summer whites." The keeper at the stern is wearing the traditional dress uniform of his rank. For all their dedication and bravery, keepers earned $400 per year in 1880, and by 1912, only $1,000. Uniforms were not included. (Courtesy Michigan Maritime Museum.)

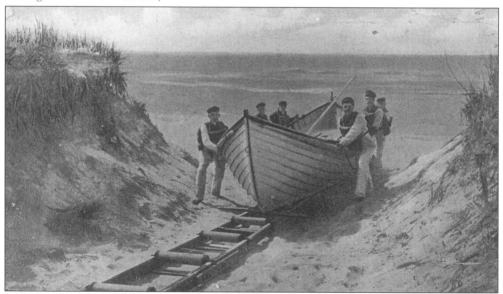

U.S LIFE-SAVING SERVICE, RETURN OF THE LIFEBOAT. After practice or a rescue, crews paid meticulous attention to stowing and drying lines and equipment. Each Monday, the keeper and crew inspected and overhauled equipment. The keeper had to obtain permission from the district superintendent in order to discard faulty equipment. (Courtesy Michigan Maritime Museum.)

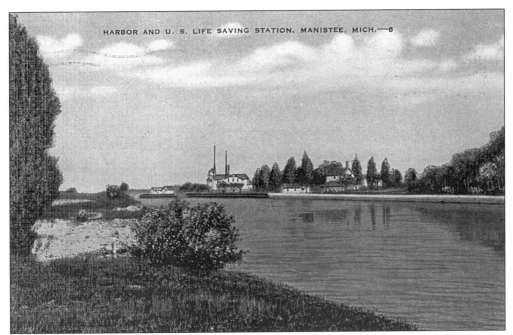

U.S. LIFE-SAVING SERVICE, MANISTEE, MICHIGAN. Built in 1879, the Manistee Station is a unique design of USLSS architect J. Lake Parkinson. No other station like this was ever built. (Courtesy Michigan Historical Center.)

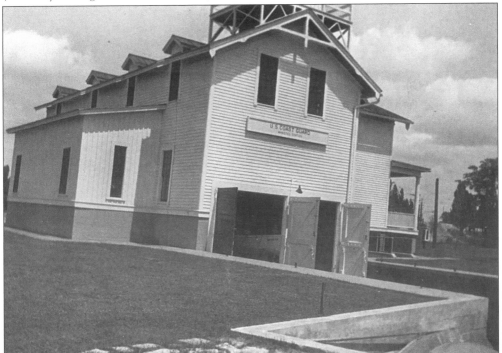

U.S. COAST GUARD STATION, MANISTEE, MICHIGAN. This photo shows the bottom portion of the lookout tower above the boathouse doors. A surfboat is visible just inside the doors. (Courtesy Michigan Historical Center.)

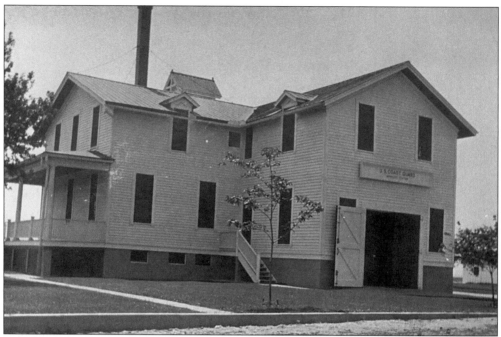

U.S. COAST GUARD, MANISTEE, MICHIGAN. This photo shows the rear of the station. By the time these photos were taken, the station had undergone some minor modifications on its original appearance. Among changes made were windows added on the second floor and rooftop dormers installed. Window dressings were also changed and chimneys were moved. (Courtesy Michigan Historical Center.)

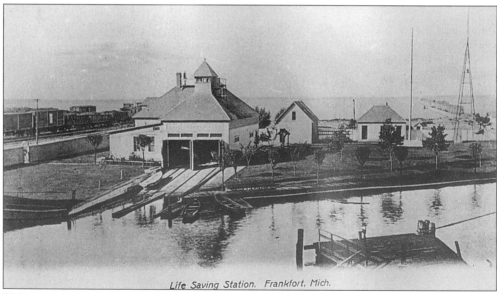

Life Saving Station. Frankfort, Mich.

U.S. LIFE-SAVING SERVICE STATION, FRANKFORT, MICHIGAN. Another example of the architecture of Albert Bibb, construction of the Frankfort Station began in 1886. This quiet view clearly shows the neatly-kept grounds of the Frankfort Station. Hints of the bustling activity surrounding the station are given by the workboats docked in front and the railcars in the background. (Courtesy Michigan Maritime Museum.)

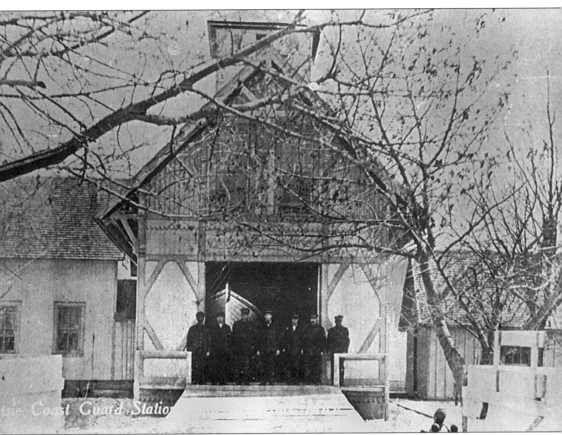

U.S. LIFE-SAVING SERVICE STATION AND CREW, FRANKFORT, MICHIGAN. The Frankfort crew are pictured in front of the station in the springtime. In Michigan, the shipping season reopened each spring with the melting of the ice. Station keepers were instructed to open the station by district superintendents. Just to the right of the boat ramp is a Manby mortar and balls. The Manby mortar was used to fire the shot and line to vessels from shore during rescues until the Lyle gun replaced it in 1878. The Lyle gun was used until 1962. (Courtesy Michigan Maritime Museum.)

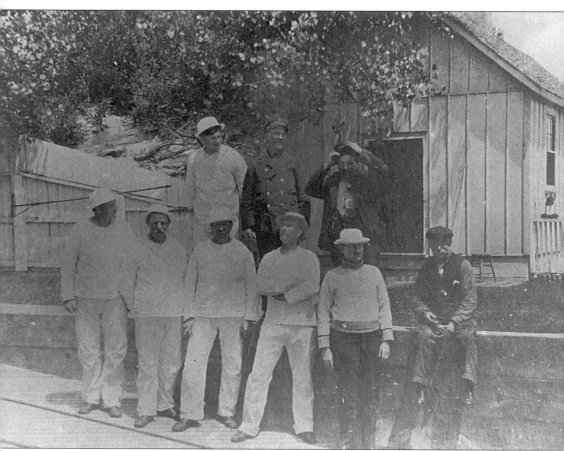

U.S. LIFE-SAVING SERVICE STATION AND CREW, FRANKFORT, MICHIGAN. This 1906 shot of a relaxed Frankfort crew shows them in their "summer whites," while the keeper in the back row, center, is wearing his dress uniform with the double-breasted coat. Several visitors are shown in the photo as well. (Courtesy Michigan Maritime Museum.)

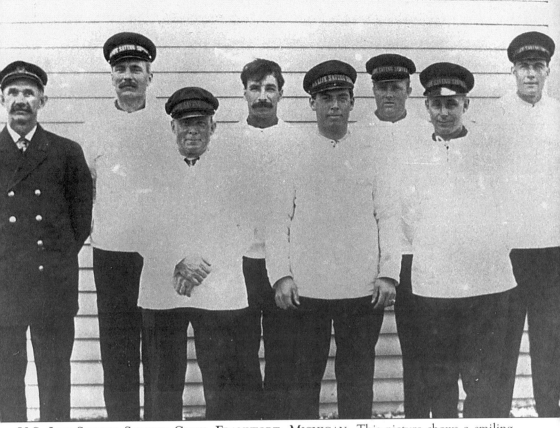

U.S. Life-Saving Service Crew, Frankfort, Michigan. This picture shows a smiling eight-man Frankfort crew. The keeper is on the far left. This shot was taken prior to 1915, as after 1915 the surfmen's hats would say "U.S. Coast Guard" instead of "U.S. Life Saving Service." Besides regular drilling and constant lookout duties, surfmen patrolled the beaches all night, every night during the shipping season. (Courtesy Michigan Maritime Museum.)

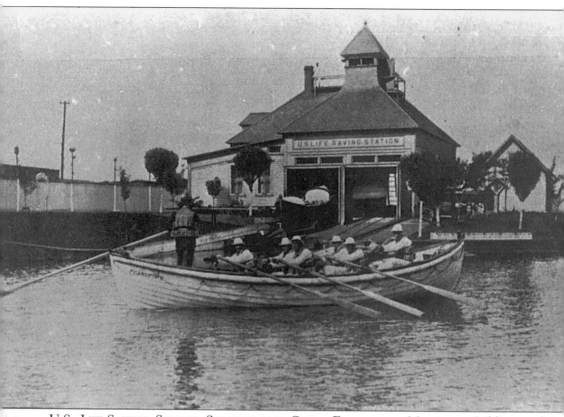

U.S. Life-Saving Service Station and Crew, Frankfort, Michigan. Lifeboat and surfboat practice typically took place on Tuesdays, as dictated by the regulations of the USLSS. In uncooperative weather, the crew could make up the practice on the next day. This 1912 shot shows six of the seven surfmen at practice in the boat. The seventh crewman is keeping watch and is standing next to the chimney on the rooftop walkway. (Courtesy National Park Service.)

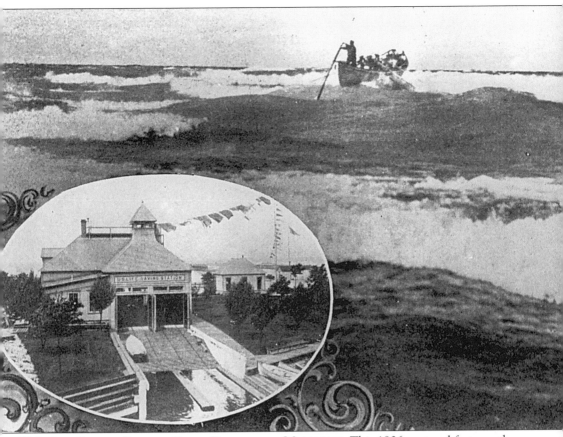

U.S. LIFE-SAVING SERVICE CREW, FRANKFORT, MICHIGAN. This 1906 postcard features the Frankfort crew and their surfboat in a brisk Lake Michigan sea. Much skill and a great amount of teamwork were required to launch the boat and maneuver safely through the breakers. Once alongside a stricken vessel, the crews had to maintain a steady course for the off-loading of passengers into the surfboat. It is suspected that panicked victims jumping recklessly into the surfboat were the cause of the drowning deaths of an entire South Carolina crew in 1876. Surfmen had to be able to calm those in peril and keep a steady head themselves. The insert of the Frankfort Station also shows a crewman on watch standing next to the chimney. (Courtesy Michigan Maritime Museum.)

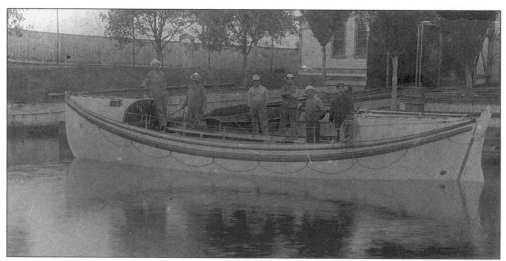

U.S. Life-Saving Service Crew, Frankfort, Michigan. This photo dated October 28, 1911, shows the Frankfort crew with the motor lifeboat. The writing on the bottom of the photo reads "this is our power lifeboat, makes about ten miles an hour." (Courtesy Michigan Maritime Museum.)

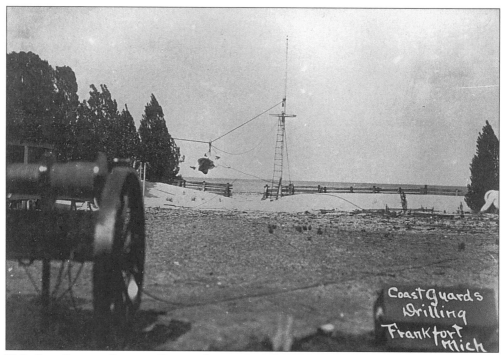

U.S. Life-Saving Service Beach Apparatus Drill, Frankfort, Michigan. While it says "Coast Guard Drilling," the photo is dated 1910, which makes it a USLSS drill. This photo clearly shows the wreck pole in the background and the lines of the beach apparatus drill. It also shows the lucky surfman who got to be the "sailor" in the drill. Barely discernable is the Lyle gun to the right of the beach cart in the very bottom of the photo. (Courtesy Michigan Maritime Museum.)

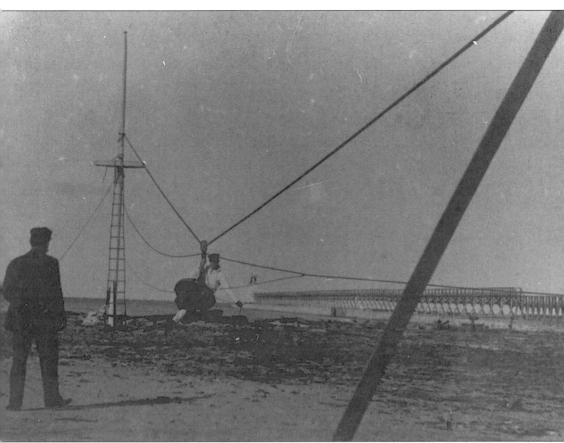

U.S. Life-Saving Service Beach Apparatus Drill, Michigan. Here is a closer view of a surfman riding the breeches buoy towards safety in a simulated rescue. The regulations governing the USLSS stipulated that the beach apparatus drill be carried out on Monday and Thursday. (Courtesy National Park Service.)

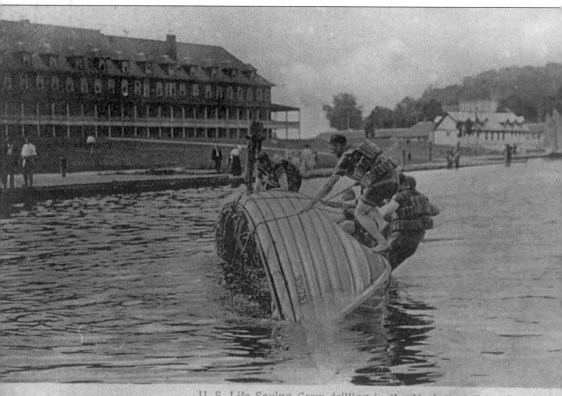

U. S. Life Saving Crew drilling in the Harbor at Frankfort, Mich

83390 Pub. by Moore & Gibson Co., N.Y. — Made in Germany

U.S. LIFE-SAVING SERVICE DRILL, FRANKFORT, MICHIGAN. This is just another regularly scheduled dunking for USLSS crewmen at Frankfort, *c.* 1909. Here the crew is drilling in front of a large hotel and its guests. Oftentimes the USLSS crews were solicited for demonstrations of their drills. The hotel is no longer there, but the town of Elberta recently restored the station. (Courtesy Michigan Maritime Museum.)

e savers at drill
Frankfort - Mich.

U.S. LIFE-SAVING SERVICE DRILL, FRANKFORT, MICHIGAN. This photo shows the Frankfort crew drilling in the harbor. Here the crew is dressed in their uniforms as opposed to their bathing suits. When this photo was taken, the hotel shown in the previous photo was gone. (Courtesy Michigan Maritime Museum.)

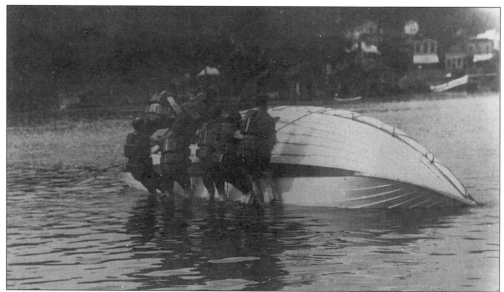

U.S. LIFE-SAVING SERVICE DRILL, FRANKFORT, MICHIGAN. This is another view of the Frankfort life-savers practicing getting the surfboat righted after a capsizing. The fact that they are wearing bathing suits may indicate that this is a photo of a demonstration as opposed to actual practice in which they would have worn their uniforms. (Courtesy National Park Service.)

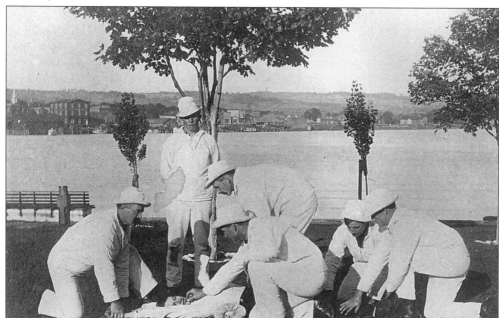

U.S. LIFE-SAVING SERVICE DRILL, FRANKFORT, MICHIGAN. On Fridays, the USLSS crews were required to practice the resuscitation of the apparently drowned. The Frankfort crew is shown here, c. 1910, practicing this drill, which involved expelling the water from the lungs as well as expanding and contracting the lungs by moving the victim's arms and legs. This method of artificial respiration worked fairly well for the Service. (Courtesy Michigan Maritime Museum.)

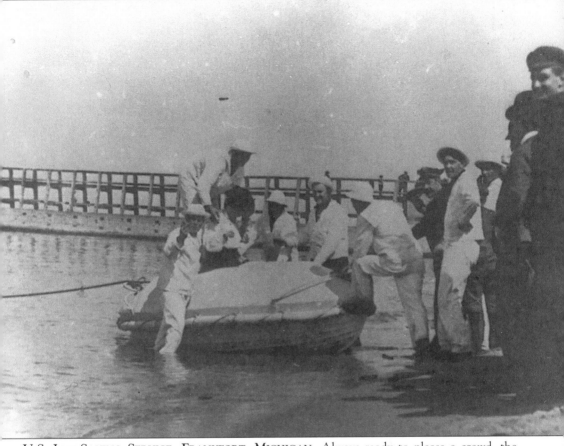

U.S. LIFE-SAVING SERVICE, FRANKFORT, MICHIGAN. Always ready to please a crowd, the Frankfort crew is shown here with the life car. It appears that the crew is preparing the woman to either enter or exit the car. Once inside, the car is sealed and brought to shore using lines run with the Lyle gun and beach apparatus. (Courtesy National Park Service.)

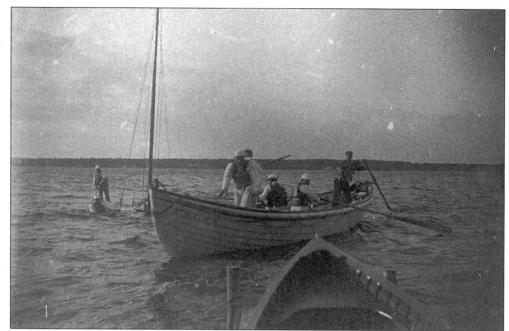

U.S. LIFE-SAVING SERVICE, FRANKFORT, MICHIGAN. This shot shows the Frankfort crew at the site of a wreck. Notice the two surfmen in the water and the top portions of a mast and rigging of a sunken ship at the bow of the surfboat. Crews not only helped in rescues, but often provided assistance and manpower in salvage efforts. Although the crews were unable to accept any fees for their salvage work, they often spent hours running line, lightening vessels, and manning pumps for salvage efforts. (Courtesy Michigan Maritime Museum.)

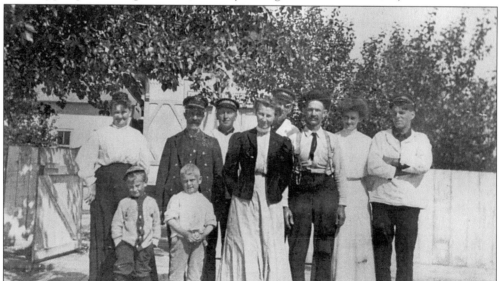

U.S. LIFE-SAVING SERVICE FAMILIES, FRANKFORT, MICHIGAN. Pictured in this *c.* 1910 photo is the keeper and three of the Frankfort surfmen with women and children. Life-saving stations were small, yet vibrant communities. The married crewmen often moved their wives and families into cottages located quite close to the station proper. Family activities around stations were common. (Courtesy Michigan Maritime Museum.)

U.S. LIFE-SAVING STATION, POINT BETSIE, MICHIGAN. Built in 1875–76, the Point Betsie Station is one of Francis W. Chandler's 1875 type station designs, featuring exterior bracing, stick work in the gables, and fancy lookout platforms. This photo shows the station from Lake Michigan. (Courtesy Michigan Maritime Museum.)

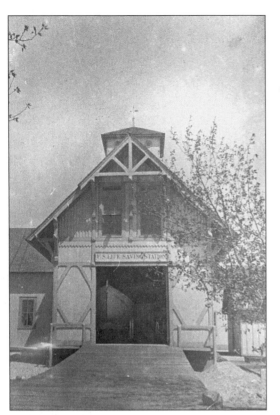

U.S. LIFE-SAVING STATION, POINT BETSIE, MICHIGAN. This shot shows the Point Betsie boathouse at the ready. The October 16, 1880 rescue of the schooner *J.H. Hartzell* is among the most famous on the Lakes. The *Hartzell* was discovered hard aground about 8:00 a.m. on the 16th, near Frankfort. The Point Betsie crew, with the help of local citizens, hauled the beach cart more than 10 miles over rough terrain in terrible weather, arriving on the scene around 11:00 a.m. They worked tirelessly until dark that evening, using the breeches buoy and life car to remove the stranded crew clinging to the mast of the vessel. A female cook was the only casualty of the day and caused considerable outrage at the time. The controversy centers around the efforts of the *Hartzell's* crew and whether or not they tried hard enough to get the cook to shore. In the end, they told Keeper Thomas Matthews that she was already dead, while an autopsy found that she drowned. (Courtesy Michigan Maritime Museum.)

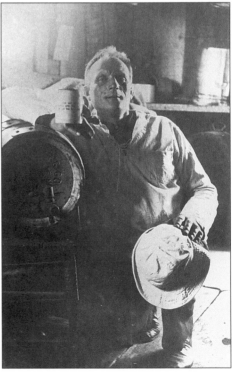

U.S. LIFE-SAVING SERVICE, POINT BETSIE, MICHIGAN. Pictured here is USLSS surfman Charles Gaul, *c.* 1910. It would be nice to know what Mr. Gaul's coffee cup says. While the keg looks like beer, USLSS rules strictly forbade alcohol at Life-Saving Service stations, with drunkenness earning a surfman immediate discharge. Mr. Gaul is undoubtedly posing for a humorous photo using whatever is in the keg as a prop. Perhaps the cask was salvaged from a wreck? (Courtesy Michigan Maritime Museum.)

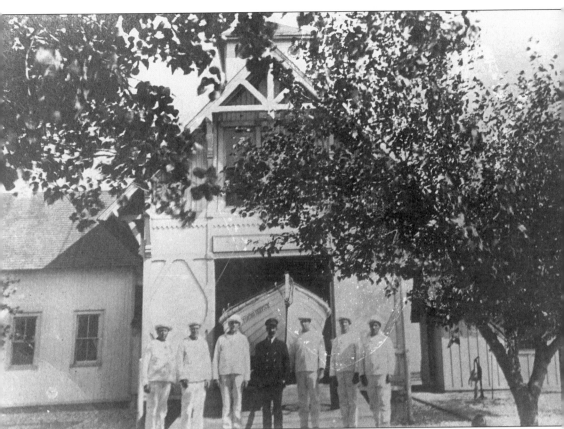

U.S. LIFE-SAVING SERVICE AND CREW, POINT BETSIE, MICHIGAN. The keeper standing in the center is Captain Bedford. Captain Bedford kept the daily log, with entries noting the activities of the crews, weather conditions, and the passage of vessels in front of the station. Charles Gaul and surfman Hendrickson are members of the crew at the time of the photo. (Courtesy Michigan Maritime Museum.)

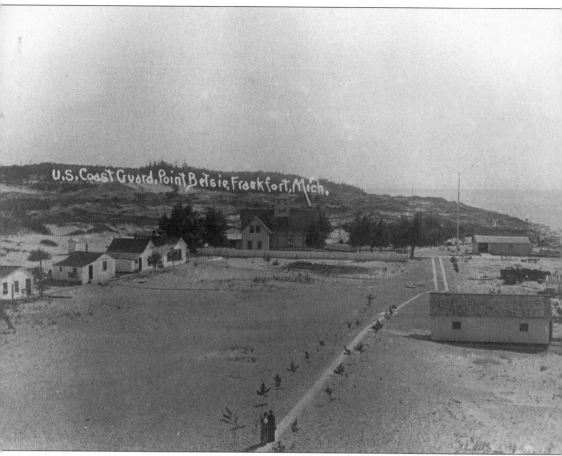

U.S. LIFE-SAVING STATION, POINT BETSIE, MICHIGAN. This *c.* 1912 photo may have been taken from the nearby lighthouse. It shows the Point Betsie Station, also known over the years as the Point au Bec Scies and Point Betsy Station. This shot clearly shows four of the surfmen's cottages to the left of the station proper. (Courtesy Michigan Maritime Museum.)

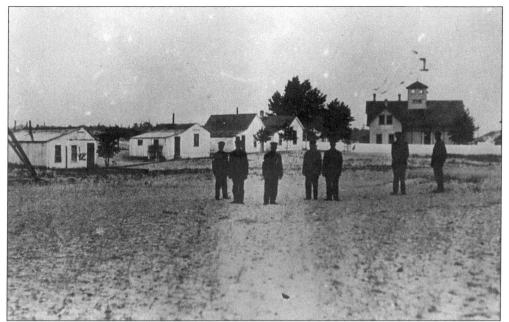

U.S. LIFE-SAVING STATION AND CREW, POINT BETSIE, MICHIGAN. Seven crew members at the Point Betsie Station pause for this photo, *c.* 1916. (Courtesy National Park Service.)

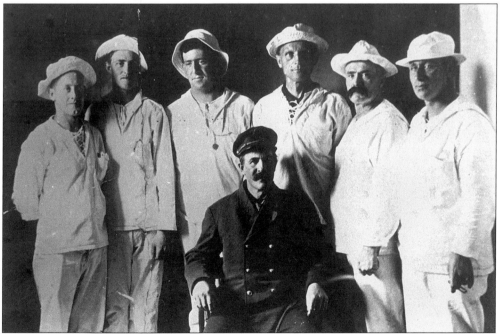

U.S. LIFE-SAVING STATION CREW, POINT BETSIE, MICHIGAN. Captain Bedford is shown here sitting with his crew for this *c.* 1910 photo. It is not known which crewman is which, but their names are John Lycutt, Dave Howard, Roy Oliver (3rd from left), Chas. Gaul, Barney ?, and Chas. Stibbets(?) at right. (Courtesy Michigan Maritime Museum and National Park Service. Both agencies had identical photos with corroborating names, although neither depicts the order of appearance.)

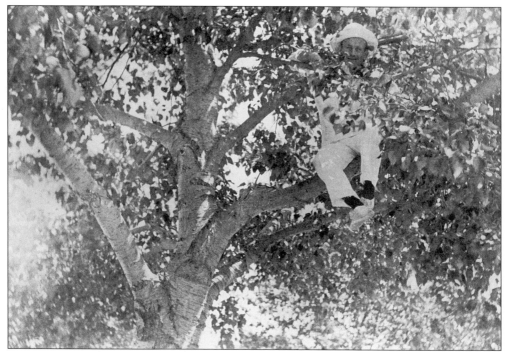

U.S. Life-Saving Service Crewman, Point Betsie, Michigan. The life of a USLSS crewman was oftentimes pretty monotonous. As you would expect, there was some goofing off allowed to pass the long hours off duty. Featured here is a Point Betsie crewman passing time in a tree. (Courtesy Michigan Maritime Museum.)

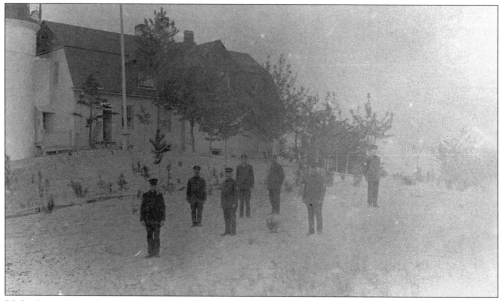

U.S. Life-Saving Service Crew, Point Betsie, Michigan. Many USLSS installations were located close to lighthouses. This *c.* 1910 photo shows Captain Bedford with his USLSS crew at the Point Betsie Lighthouse along with crew members of the U.S. Lighthouse Service, which merged into the Coast Guard in 1939. (Courtesy Michigan Maritime Museum.)

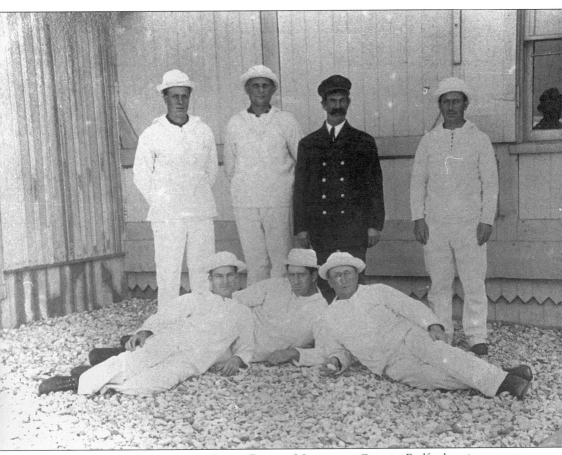

U.S. LIFE-SAVING SERVICE CREW, POINT BETSIE, MICHIGAN. Captain Bedford again pauses with his crew for a photo, *c.* 1910. Captain Bedford is in the dark coat. His crew for that season included Charles Stibbets, Charles Gaul, Sig ?, ? Hess, Roy Oliver, and ? Hendrickson. (Courtesy Michigan Maritime Museum.)

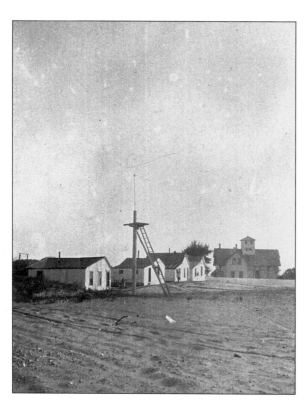

U.S. Life-Saving Service Station, Point Betsie, Michigan. The practice mast, or wreck pole, for the beach apparatus drill is shown in this photo next to the cottages of the crewman at the Point Betsie Station. (Courtesy Michigan Maritime Museum.)

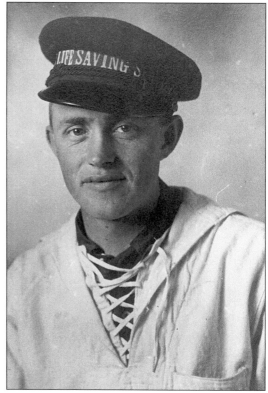

U.S. Life-Saving Service Crewman, Point Betsie, Michigan. Meet USLSS surfman Dave Howard. When this photo was taken, *c.* 1910, a crewman like Mr. Howard earned about $60 a month. Health benefits were nonexistent, and if he were killed in the line of duty, his family would likely end up destitute. Because of the relatively low pay and hazardous conditions, the Service often attracted immigrants. According to Dennis Noble, a historian of the USLSS, 29% of the surfmen and 40% of keepers on Lake Michigan from 1871–1913 were foreign-born.

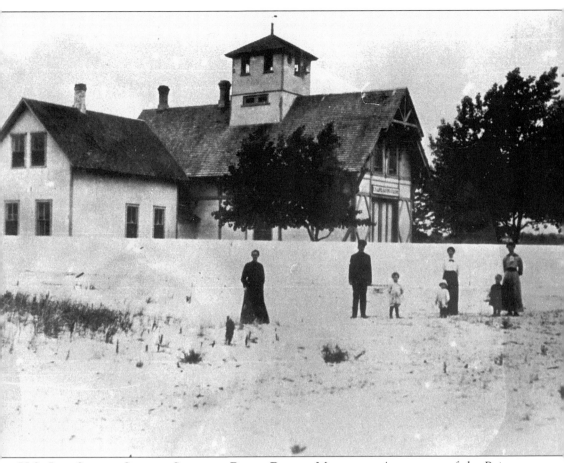

U.S. Life-Saving Service Station, Point Betsie, Michigan. A crewman of the Point Betsie Station pauses for a photo with women and children in front of the station. These are probably some of the wives of the Point Betsie crew. (Courtesy National Park Service.)

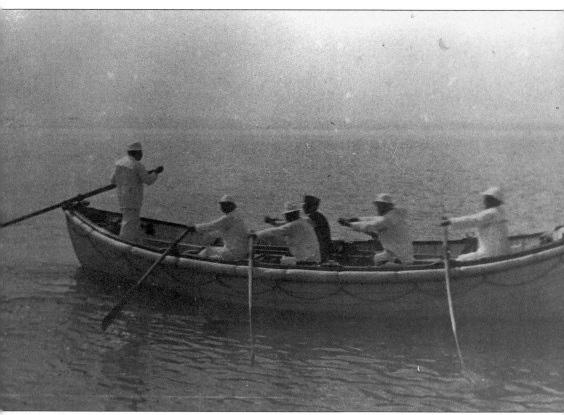

U.S. LIFE-SAVING SERVICE CREW, POINT BETSIE, MICHIGAN. Here the crew of the Point Betsie Station is practicing with the surfboat. Boat practice took place on Tuesday at all stations. (Courtesy National Park Service.)

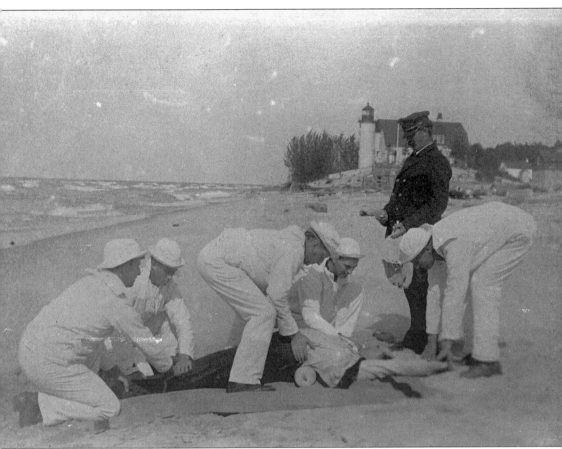

U.S. Life-Saving Service Crew, Point Betsie, Michigan. Friday at Point Betsie meant time to practice the resuscitation of the apparently drowned. Here the crew performs the drill under the watchful eye of Keeper Bedford. As was often the case, the keeper timed his men and their performance in preparation for their quarterly inspection by the district superintendents. (Courtesy Michigan Maritime Museum.)

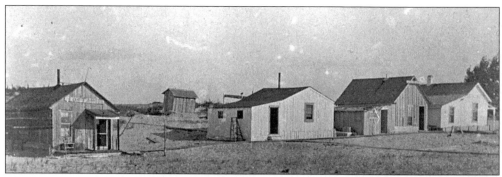

U.S. LIFE-SAVING SERVICE, POINT BETSIE, MICHIGAN. This *c.* 1910 photo shows the cottages of the USLSS crew at Point Betsie. Crews and their families were often pretty creative in finding ways to liven up their communities. At Point Betsie, they gave the buildings funny names and hung interesting signs. Off-duty hours were spent cutting and hauling wood, on home maintenance and construction, or familial duties. (Courtesy Michigan Maritime Museum.)

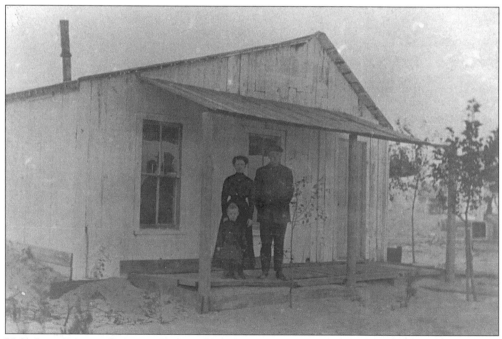

U.S. LIFE-SAVING SERVICE, POINT BETSIE, MICHIGAN. Here is the family of one of Point Betsie's dedicated USLSS surfmen, taken *c.* 1910. While remote, the summer climate and location of these stations was ideal. In Michigan, the men of the USLSS supplemented their supplies and meager living through hunting and fishing. (Courtesy Michigan Maritime Museum.)

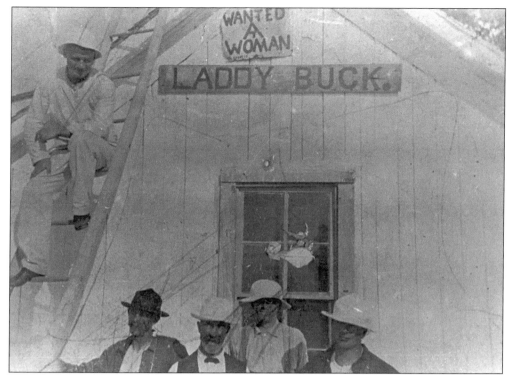

U.S. Life-Saving Service, Point Betsie, Michigan. There is little mistake what these crewmen were after at Point Betsie in 1914. A sense of humor was essential to make the most out of life at the remote USLSS stations. In several instances around the state, surfmen were given proper leaves of absences by their keeper to get married. (Courtesy National Park Service.)

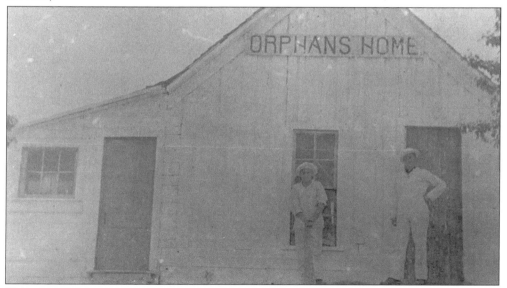

U.S. Life-Saving Service, Point Betsie, Michigan. Apparently, the crew were free to name their cottages, as they did in this *c.* 1912 photo. This practice became quite common at Point Betsie. (Courtesy Michigan Maritime Museum.)

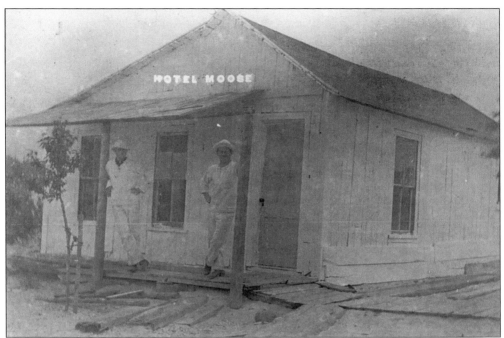

U.S. Life-Saving Service, Point Betsie, Michigan. USLSS crewmen Dave Howard and John Lycutt outside the "Hotel Moose" at the Point Betsie Station. Upon becoming part of the USCG, crews finally became eligible for pensions with the number one surfmen ranking as a petty officer and the keepers as warrant officers. (Courtesy Michigan Maritime Museum.)

U.S. Life-Saving Service, Point Betsie, Michigan. Here are the Point Betsie surfmen and their families making a home for themselves on Lake Michigan. Besides their duties with the USLSS, the crews also had the everyday duties and chores of their civilian lives. Notice the lighthouse in the right rear of this *c.* 1912 photo. (Courtesy Michigan Maritime Museum.)

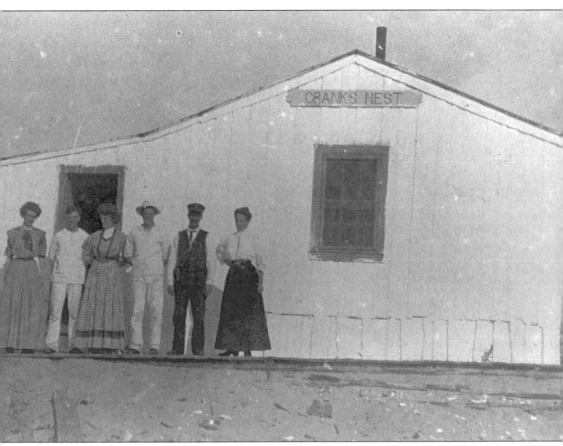

U.S. Life-Saving Service, Point Betsie, Michigan. Pictured here in 1910 are U.S. Life-Saving Service crewmen and three women. The couple on the right is Keeper Bedford and his wife. In order to earn a pension after the 1915 change, a keeper had to serve no less than 30 years. (Courtesy Michigan Maritime Museum.)

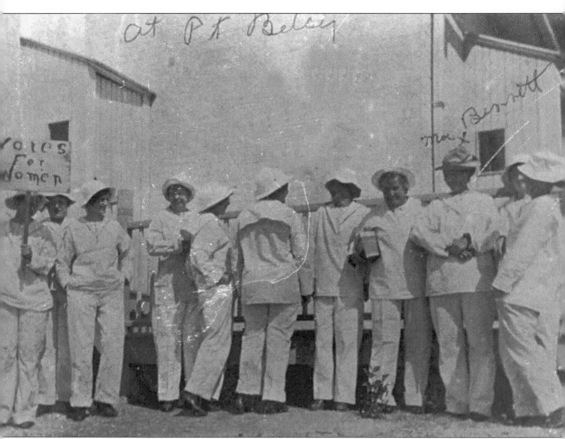

U.S. Life-Saving Service, Point Betsie Michigan. In this *c.* 1914 photo, the women of Point Betsie are protesting the fact that women did not win the right to vote until the 19th amendment to the Constitution was passed in 1920. In this photo they are wearing the summer uniforms of the USLSS. Only Mrs. Bennett is identified, standing third from right. (Courtesy National Park Service.)

U.S. LIFE-SAVING SERVICE, POINT BETSIE MICHIGAN. While the women had pressing concerns such as suffrage to deal with, the men used their sense of humor to find amusing ways of passing the time. Here crewman Dave Howard clowns around in the hopes of getting a good-night kiss, c.1910. (Courtesy Michigan Maritime Museum.)

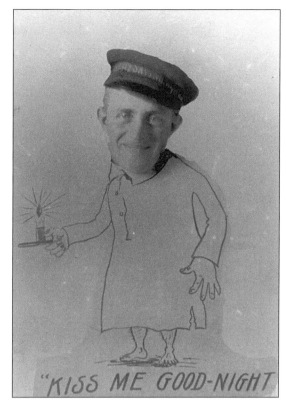

"KISS ME GOOD-NIGHT"

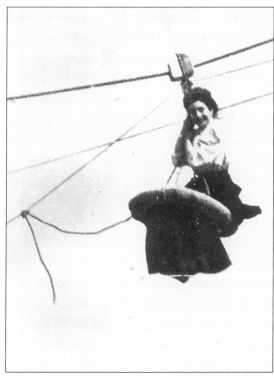

U.S. LIFE-SAVING SERVICE, POINT BETSIE MICHIGAN. This photo shows the keeper's daughter enjoying her ride in the breeches buoy down from the wreck pole during the breeches buoy drill. (Courtesy National Park Service.)

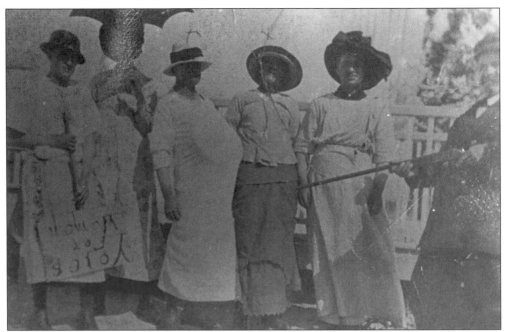

U.S. LIFE-SAVING SERVICE, POINT BETSIE MICHIGAN. Here are the men of Point Betsie clowning around in women's clothes. In this *c.* 1914 photo, they are getting ready to have a "shotgun wedding." The keeper is on the right holding the shotgun. (Courtesy National Park Service.)

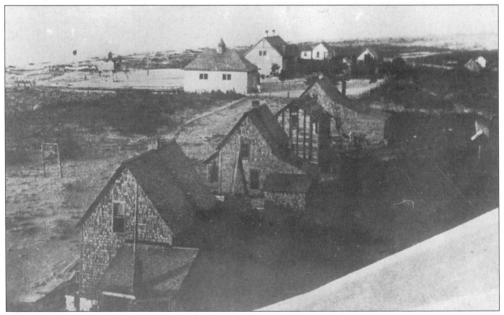

U.S. LIFE-SAVING SERVICE, SLEEPING BEAR POINT, MICHIGAN. Built in 1901, the Sleeping Bear Point Station is a Marquette type also designed by Albert B. Bibb. This 1912 photo clearly shows the homes of the USLSS crew lined up south of the station. Today the National Park Service operates this station and owns several of the crew's homes. (Courtesy National Park Service.)

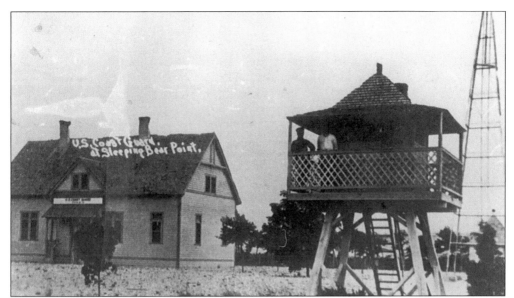

U.S. Coast Guard Station, Sleeping Bear Point, Michigan. Keeping watch in the watchtower was part of the daily routine for life-savers. This photo shows the watchtower, signal flag tower, and the station house. Relocated in the 1930s, this station house is now a maritime museum, and the boathouse is fully restored with USLSS equipment. (Courtesy National Park Service.)

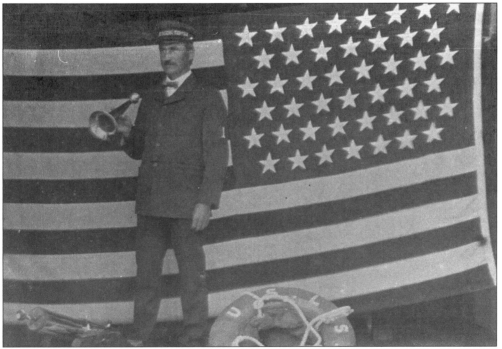

U.S. Life-Saving Service, Michigan. This patriotic life-saver is Charles Robinson, shown in front of a 45-star U.S. flag with the breeches buoy, traveling block, and the polished Lyle gun. Robinson served in the USLSS from 1900–1914. This photo is probably from Sleeping Bear Point. (Courtesy National Park Service.)

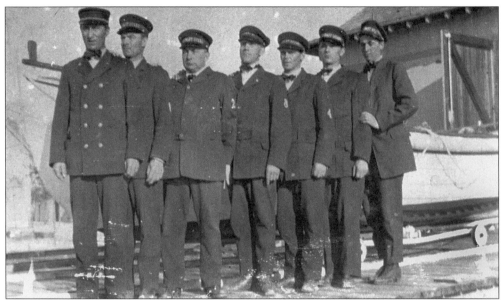

U.S. COAST GUARD CREW, SLEEPING BEAR POINT, MICHIGAN. This photo from the 1920s shows the keeper and his six surfmen lined up in order from left to right. Although it has been known as the Coast Guard since 1915, little in the daily lives of the crews changed until later. (Courtesy National Park Service.)

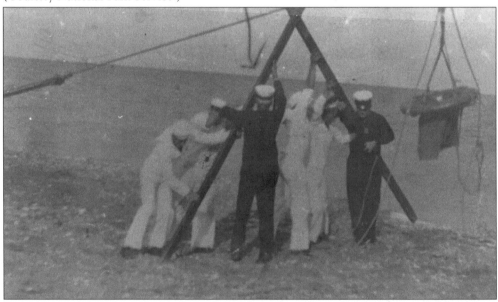

U.S. COAST GUARD CREW, SLEEPING BEAR POINT, MICHIGAN. The USCG crew is setting up the shoreside equipment for the beach apparatus drill. The arrow is pointing to the station commander, who may be a man named Fred Marsh. The "crotch" is being hoisted by the crew and was used to elevate and tighten the hawser line on which the breeches buoy and traveling block (pulley) rode. The line disappearing to the left of the crotch is connected to the sand anchor, an X-shaped set of 2-inch by 12-inch boards buried deeply in the sand. This system kept lines tight and enabled the transfer of thousands of people from wrecked vessels to shore during the years of its use. (Courtesy National Park Service.)

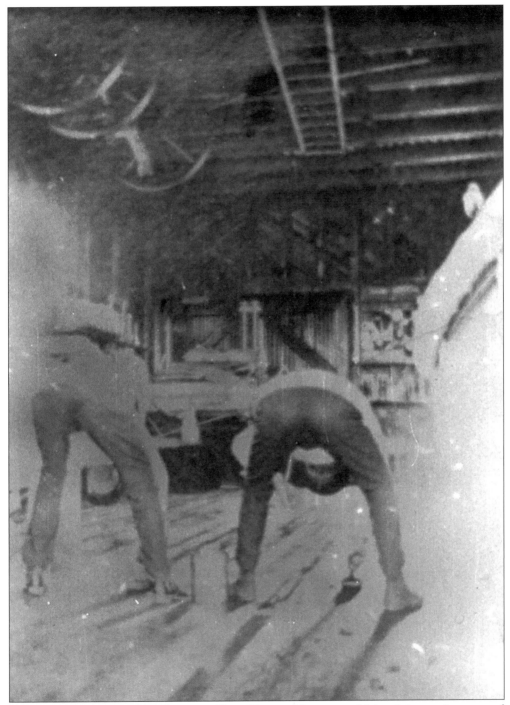

U.S. LIFE-SAVING SERVICE, SLEEPING BEAR POINT, MICHIGAN. Maintaining equipment and keeping everything in working order was scheduled for Monday and Saturday. This shot shows two USLSS surfmen varnishing the boathouse floor. Sometimes the keeper would enlist the help of surfmen for large chores in the winter when the stations were closed. (Courtesy National Park Service.)

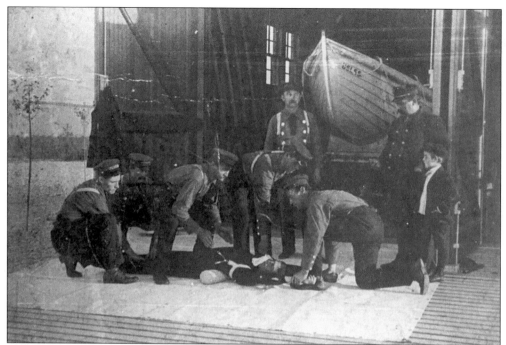

U.S. LIFE-SAVING SERVICE, SLEEPING BEAR POINT, MICHIGAN. This 1904 shot shows the Sleeping Bear Point crew practicing the resuscitation of the apparently drowned. The keeper is timing the crew while a small boy looks on. (Courtesy National Park Service.)

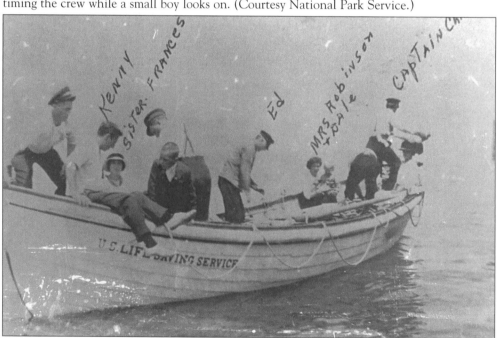

U.S. LIFE-SAVING SERVICE, SLEEPING BEAR POINT, MICHIGAN. Life was not all work for the members of the USLSS. Shown here is the Robinson family in the pulling lifeboat around 1910. Captain Charles Robinson is in the stern of the boat with the steering oar, with other USLSS crew members scattered amongst his family. (Courtesy National Park Service.)

U.S. LIFE-SAVING SERVICE, SOUTH MANITOU ISLAND, MICHIGAN. Built in 1901, the South Manitou Island Station is also Bibb's Marquette type. This U.S. Coast Guard photo from 1926 shows the station grounds and beach from inside the boathouse. Hanging from the rafters in the center top of the photo is the life car. (Courtesy National Park Service.)

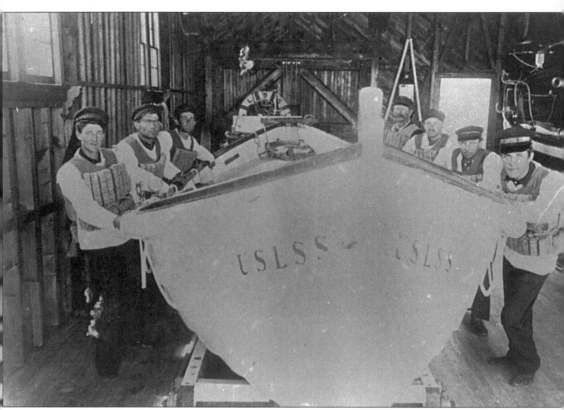

U.S. LIFE-SAVING SERVICE, SOUTH MANITOU ISLAND, MICHIGAN. Pictured here getting ready for a launch is the 1906 crew of South Manitou Island. Left to right are surfmen #5, John K. Tobin; #3, James Mikula; #1, George I. Haas; Keeper Jacob VanWeldon; #2, Martin Furst; #4, George Kelderhouse; and #6, Harold Barnard. (Courtesy National Park Service.)

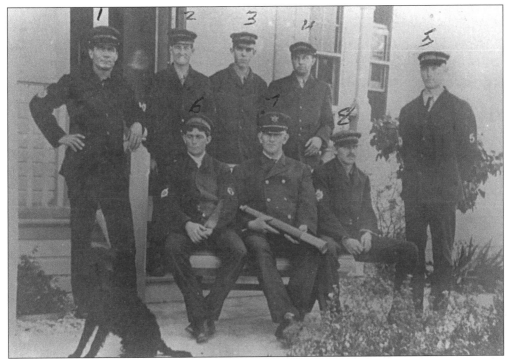

U.S. LIFE-SAVING SERVICE, SOUTH MANITOU ISLAND, MICHIGAN. The *c.* 1910 crew of the South Manitou Island Station consisted of Pat McCally, John Tobin, unidentified, George Kelderhouse, Theodore Thompson, Harold Barnard, Keeper Eli Pugh, and Martin Furst, as well as a canine companion. (Courtesy National Park Service.)

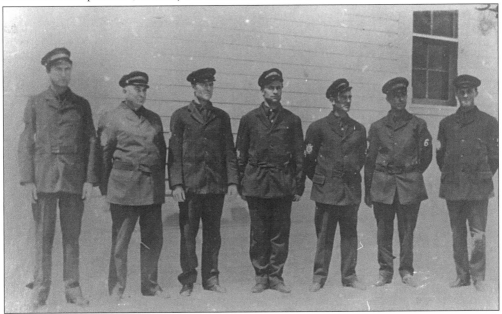

U.S. LIFE-SAVING STATION, SOUTH MANITOU ISLAND, MICHIGAN. This is the crew of Captain Charles Robinson in their dress uniforms in front of the station. (Courtesy National Park Service.)

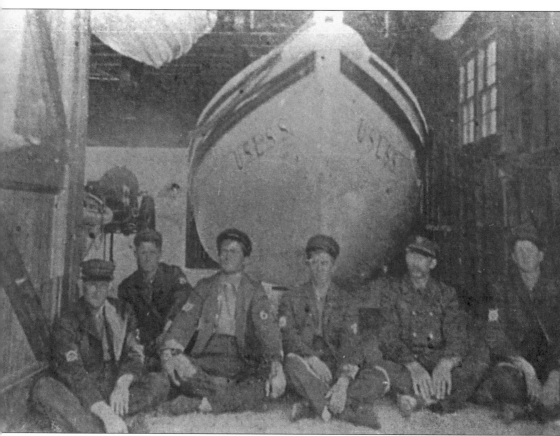

U.S. Life-Saving Station, South Manitou Island, Michigan. This 1909 shot features surfmen (L-R) George Haas, Martin Furst, Jim Mikula, Harold Barnard, Captain VanWeldon, and John Tobin sitting in front of the boathouse. The beach cart and boat can be seen in the background, and the life car is hanging above them. (Courtesy National Park Service.)

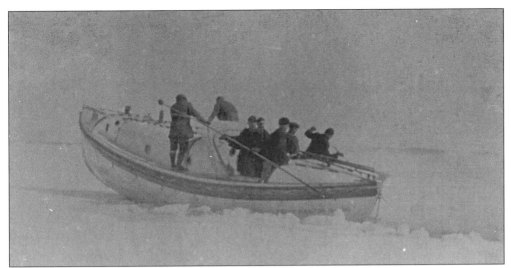

U.S. COAST GUARD, SOUTH MANITOU ISLAND, MICHIGAN. As vessels became larger and stronger, the shipping season extended later into the year. Ice and duty in increasingly cold weather was a problem that crews had to contend with. This 1925 photo shows the South Manitou Island motor lifeboat working in Lake Michigan ice. Coast Guard ice breakers are a regular site around the Lakes today, and the shipping season now runs into January. At times surfmen on these island stations got across to the mainland in winter by crossing the ice on horseback. (Courtesy National Park Service.)

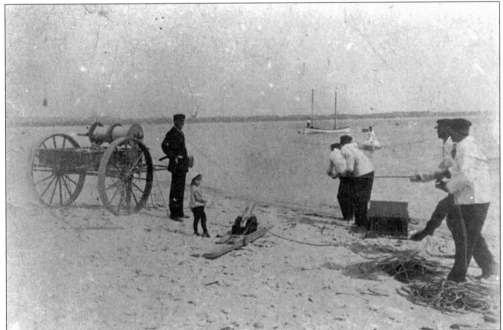

U.S. LIFE-SAVING SERVICE, SOUTH MANITOU ISLAND, MICHIGAN. This photo shows the South Manitou Island crew practicing with the life car. The box on the ground in between the two groups of surfmen is the faking box. The rope fired by the Lyle gun was coiled, or faked, around the pegs of this box, eliminating tangles as the rope played out behind the messenger. (Courtesy National Park Service.)

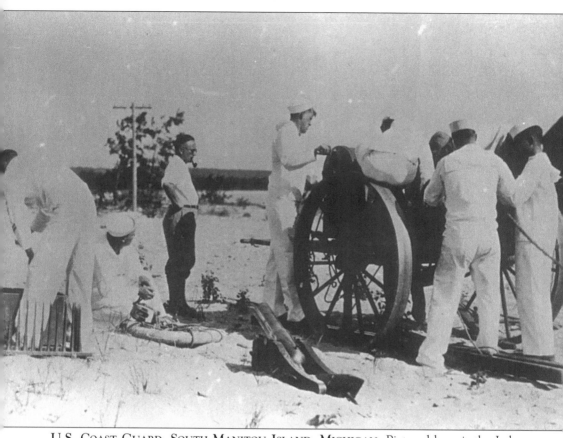

U.S. Coast Guard, South Manitou Island, Michigan. Pictured here is the Lyle gun, breeches buoy, faking box, and the beach cart as the crew begins stowing the gear back in the cart after this beach apparatus drill in the late 1920s. The crotch hangs below the axle of the cart. All the necessary equipment fit into this compact cart for easy transportation to remote wrecks. (Courtesy National Park Service.)

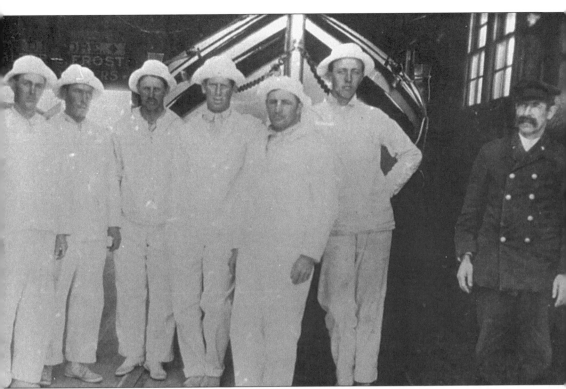

U.S. Life-Saving Service, South Manitou Island, Michigan. The keeper on the far right is distinguishable by the double-breasted coat of his uniform. Surfmen's uniforms were single-breasted. These surfmen are in their cooler "summer white" work uniforms. (Courtesy National Park Service.)

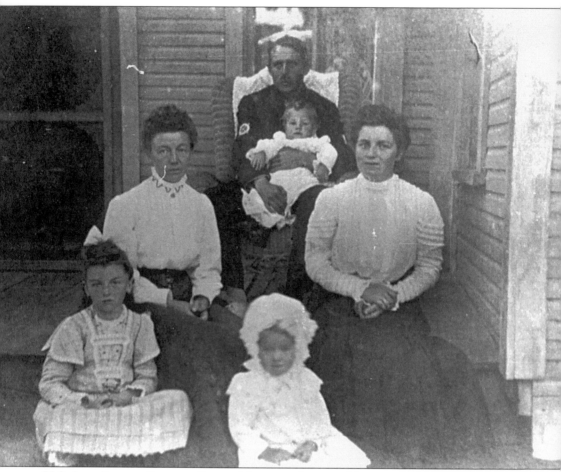

U.S. Life-Saving Service, South Manitou Island, Michigan. Shown here, *c.* 1910, is surfman Martin Furst holding his son Norman C. Furst. His wife Zella is on the left, and their daughter Ethel is in the foreground. The other woman is Mrs. John Frehse with daughter Fernette Frehse. Children growing up at stations witnessed the daily activities of their fathers and shared the concerns of their mothers when the weather turned foul. (Courtesy National Park Service.)

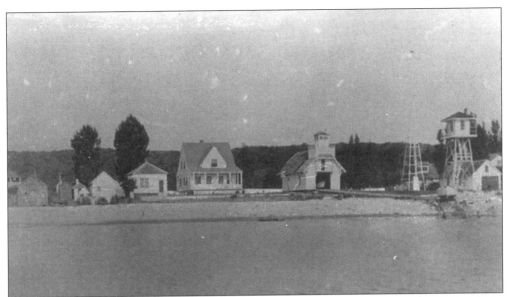

U.S. LIFE-SAVING SERVICE STATION, NORTH MANITOU ISLAND, MICHIGAN. Built in 1875–76, this is Francis Chandler's 1875 style, featuring the clipped gable. Though access to this station is only by boat, there is quite a community surrounding it. Notice the long ramp from the boathouse to the water with the lifeboat sitting on it. At one point, a Great Lakes keeper asked for permission to place a stool in the lookout tower. This request was denied by the district superintendent. (Courtesy National Park Service.)

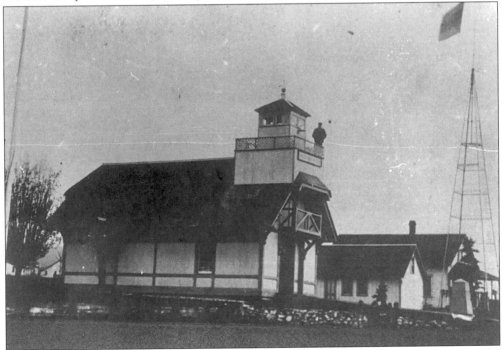

U.S. LIFE-SAVING SERVICE STATION, NORTH MANITOU ISLAND, MICHIGAN. This c. 1910 photo shows the signal flag tower on the right and a USLSS crewman keeping watch in the rooftop lookout on the boathouse. (Courtesy National Park Service.)

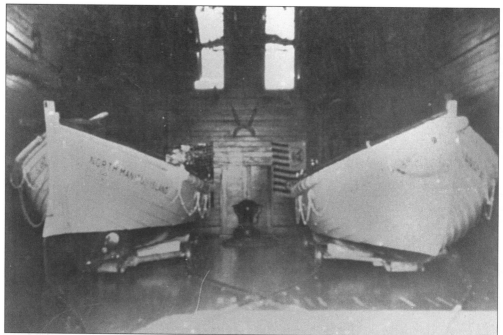

U.S. LIFE-SAVING SERVICE STATION, MICHIGAN. Both boats are ready in this photo. Worthy of notice here is the finished interior of the boathouse. Often the boathouses were left unfinished with exposed wall studs. (Courtesy National Park Service.)

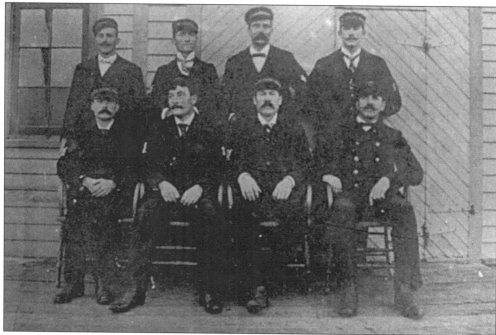

U.S. LIFE-SAVING SERVICE CREW, NORTH MANITOU ISLAND, MICHIGAN. Pictured here is Captain Abraham Anderson and his 1897 crew. Keeper Anderson is seated on the far right. As was the current fashion, all but one of the surfmen are sporting a mustache. (Courtesy National Park Service.)

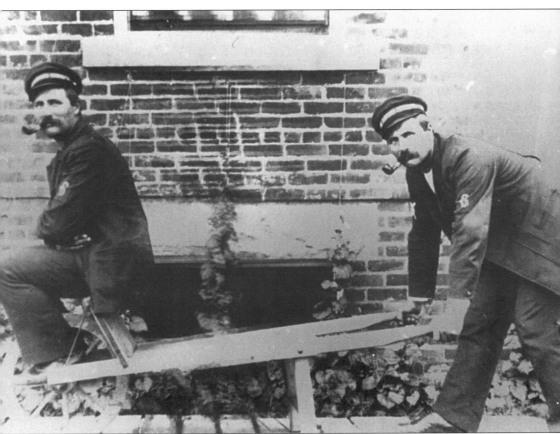

U.S. Life-Saving Service Crewman, North Manitou Island, Michigan. Crewman Hans P. Halseth uses a photographic trick to place himself at both ends of the handcart. The photographer double-exposed this negative to make the illusion that Hans was in two places at once, which also explains the slightly blurry quality of the print. (Courtesy National Park Service.)

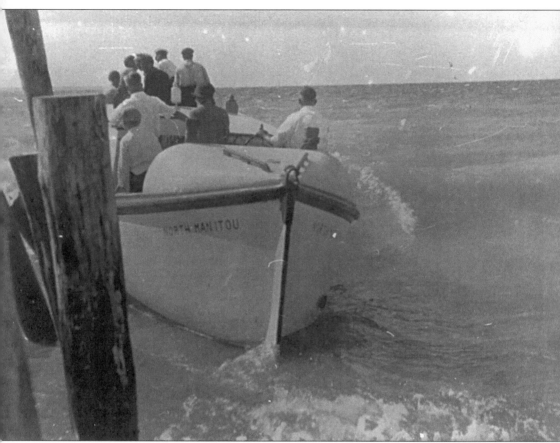

U.S. Coast Guard, North Manitou Island, Michigan. This 1934 photo shows the crew of North Manitou Island maneuvering the motor lifeboat with a load of passengers away from the dock into the Lake Michigan swells. Crews used the boats for their everyday transportation as well as for rescues. (Courtesy National Park Service.)

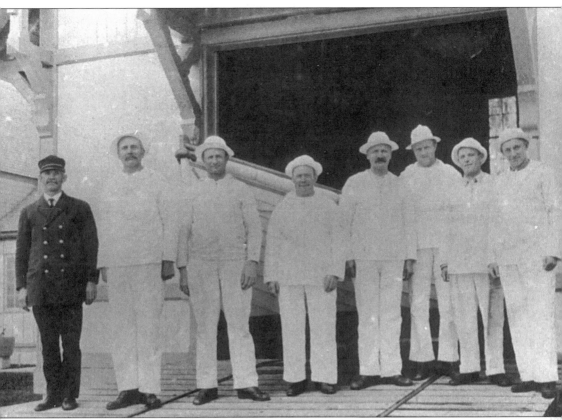

U.S. Life-Saving Service Crew, North Manitou Island, Michigan. In no particular order (l-r?), this photo shows the 1892 crew of the North Manitou Island Station. Keeper Sammet (on the far left), Abraham Anderson, Tom Laird, Lewis Dustin, Hans Halseth, John Basch, Charles McCauley, and Roy Vert are among the crew. While the men are identified, the location of this photo may be suspect as the keeper is the same as in the photo on page 39. It was not unusual, however, for keepers and surfmen to move around to other stations. (Courtesy National Park Service.)

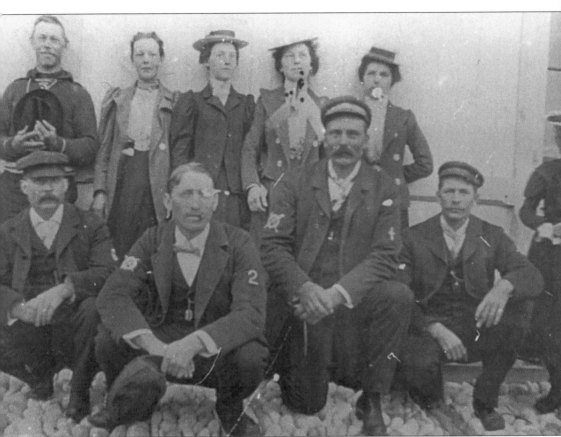

U.S. Life-Saving Service Crew, North Manitou Island, Michigan. Pictured here is the North Manitou Island crew on August 8, 1900. Unfortunately the men and women shown here are unidentified, although the number four surfman kneeling in the center appears to be Hans Halseth. (Courtesy National Park Service.)

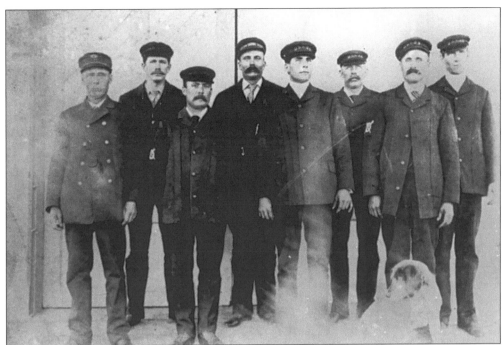

U.S. LIFE-SAVING SERVICE CREW, NORTH MANITOU ISLAND, MICHIGAN. From left to right, this early photo of the North Manitou Island crew consists of the unidentified keeper (possibly Captain Sammet); #2, unidentified; #3, ? Dustin; #4, A. Anderson; #5, unidentified; #6, unidentified; #7, Hans Halseth; and #8, Bill Carlson. (Courtesy National Park Service.)

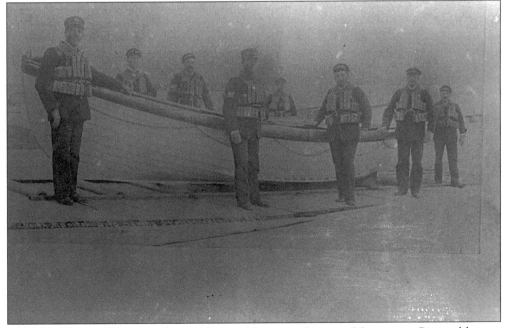

U.S. LIFE-SAVING SERVICE CREW, NORTH MANITOU ISLAND, MICHIGAN. Pictured here is Captain Sammet and his crew preparing for boat practice with their surfboat on July 14, 1897. (Courtesy National Park Service.)

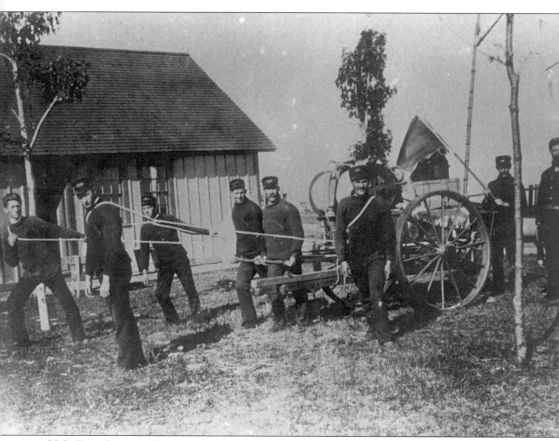

U.S. Life-Saving Service Crew, North Manitou Island, Michigan. Here is the 1893 crew of North Manitou Island with the fully loaded beach cart. As was often the case, the crew members pulled the cart long distances to rescues. This photo clearly shows how they accomplished this feat. Also note that several of the crewmen are wearing heavy USLSS-issue sweaters. The bearded keeper is on the far right. (Courtesy National Park Service.)

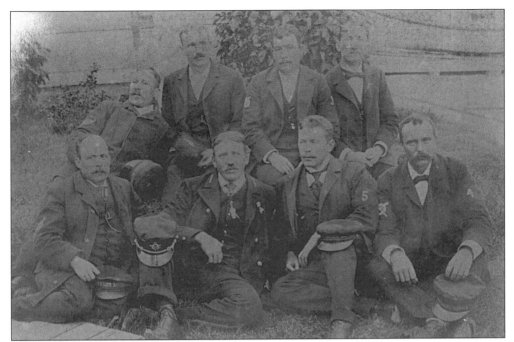

U.S. LIFE-SAVING SERVICE CREW, NORTH MANITOU ISLAND, MICHIGAN. In the front row, second from left, is the keeper of the North Manitou Island crew. Apparently, the number four surfman in the front row, far right, is Hans Halseth. (Courtesy National Park Service.)

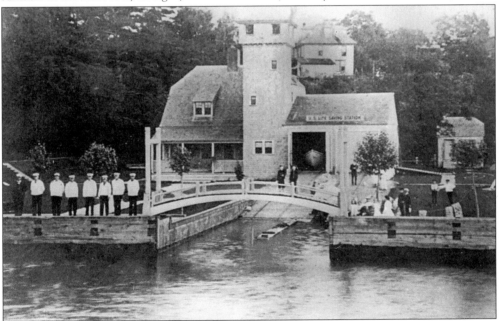

U.S. LIFE-SAVING STATION, CHARLEVOIX, MICHIGAN. Built in 1899, the Charlevoix Station is a Duluth type, designed by USLSS architect George R. Tolman. The USLSS built only three of these stations in Michigan. Again, the popularity of the Service and the stations are noted by the large number of visitors on the grounds when the photo was taken. (Courtesy National Park Service.)

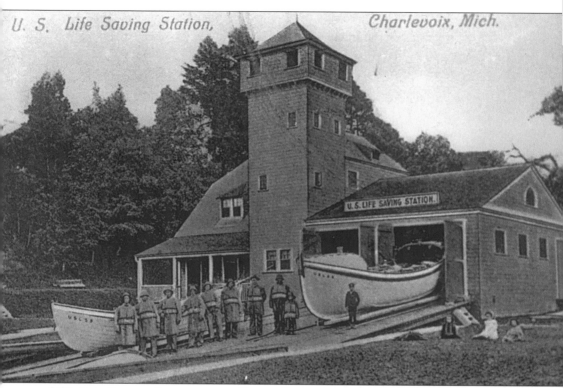

U.S. LIFE-SAVING STATION AND CREW, CHARLEVOIX, MICHIGAN. The Charlevoix crew pauses for a picture with their lifeboat (right) and surfboat (left). They are wearing their rain gear for this August 1908 photo. They also outfitted a child just to the right of the last crewman with USLSS rain gear for the photo. This must have been quite exciting for a youngster. (Courtesy Michigan Maritime Museum.)

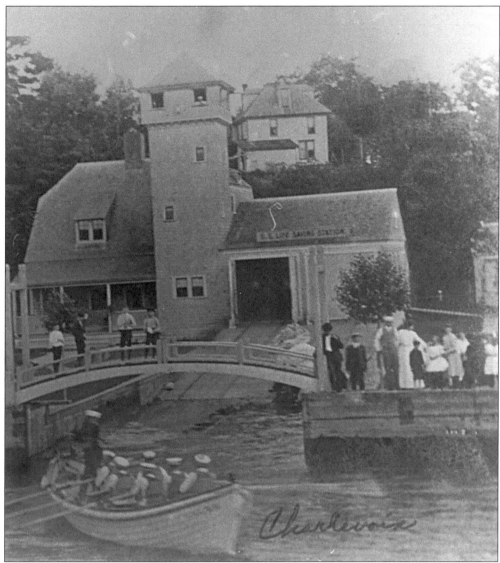

U.S. LIFE-SAVING STATION AND CREW, CHARLEVOIX, MICHIGAN. The USLSS crew with a keeper and six crewmen on the oars are leaving the Charlevoix Station as the crowd looks on. Most times the drilling and practice of the USLSS crews drew crowds, with no exception here. (Courtesy National Park Service.)

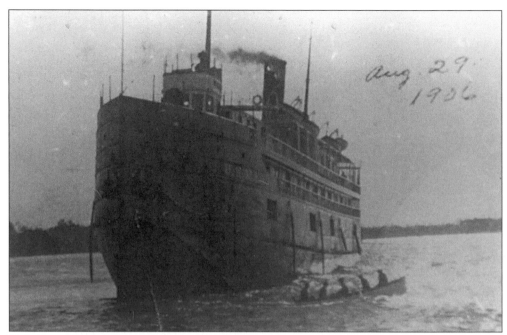

U.S. Life-Saving Service Crew, Charlevoix, Michigan. On August 29, 1906, some of the Charlevoix life-savers manned a boat to get their mail. Note the considerable waves, as the boat appears to have very little freeboard. Crews all looked forward to mail, which sometimes contained new reading material sent to stations by the USLSS's women's auxiliary. (Courtesy National Park Service.)

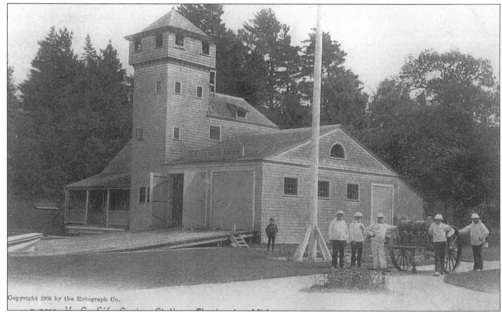

U.S. Life-Saving Station and Crew, Charlevoix, Michigan. This c. 1905 postcard view is a good representation of several of the Charlevoix crew with the loaded beach cart. As was always the case, there is a surfman on duty visible in the lookout tower. (Courtesy Michigan Maritime Museum.)

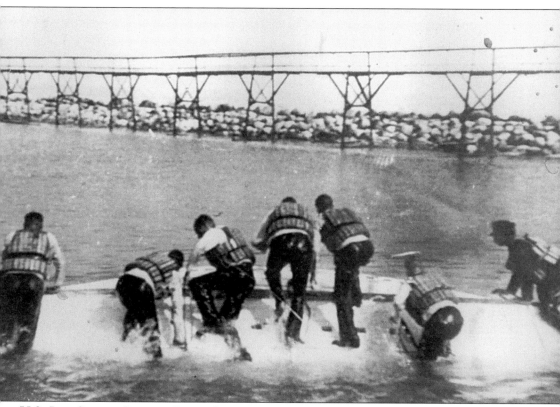

U.S. LIFE-SAVING SERVICE CREW, CHARLEVOIX, MICHIGAN. Getting a good dousing in the cold Lake Michigan water, these fully uniformed USLSS crewman scramble onto the bottom of their overturned boat. The keeper on the far right will stay ahead of the surfmen. Some keepers were so agile at this, they barely got their feet wet during this drill. (Courtesy National Park Service.)

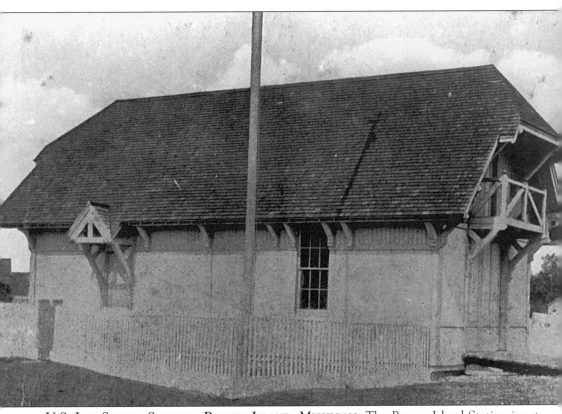

U.S. Life-Saving Station, Beaver Island, Michigan. The Beaver Island Station is yet another example of Francis Chandler's work. This photo was taken after the Service became the Coast Guard. (Courtesy Michigan Maritime Museum.)

Two

LAKE HURON

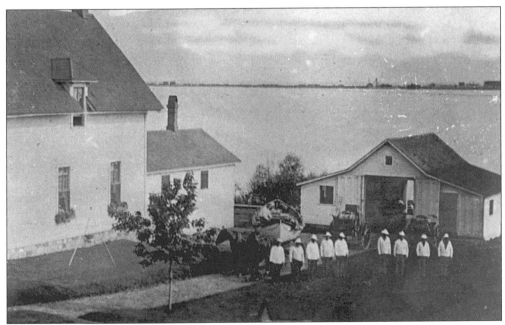

U.S. LIFE-SAVING SERVICE STATION, HARBOR BEACH, MICHIGAN. A fine example of the architecture of J. Lake Parkinson, this 1879 type station opened at Harbor Beach in 1881. Pictured here is a large crew with a horse hooked up to the surfboat wagon. Although the USLSS often used the horses of nearby residents, they never kept any of their own for that purpose. The beach cart is behind the crew fully loaded and ready for action. (Courtesy Michigan Maritime Museum.)

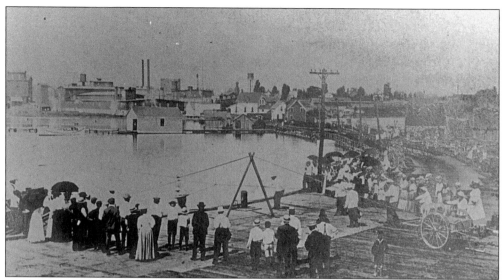

U.S. COAST GUARD STATION, HARBOR BEACH, MICHIGAN. This 1921 postcard shows what is probably the Harbor Beach crew in a demonstration with the beach apparatus. The caption on the photograph reads, "Mason's from Detroit at H.B. July 22.21." Exhibition drills were popular and allowed by the Service as long as proper authorization was obtained from district superintendents. These were quite convenient for the Harbor Beach crew, as this was the location of the Lakes Huron and Superior district superintendents' office. (Courtesy Michigan Maritime Museum.)

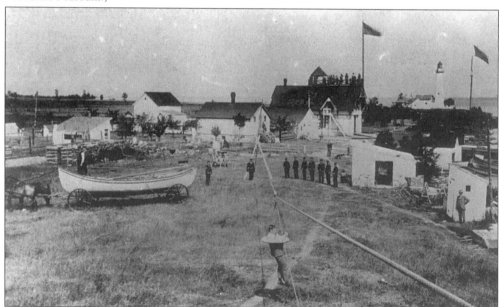

U.S. LIFE-SAVING SERVICE, POINT AUX BARQUES, MICHIGAN. A busy day at the Point aux Barques Station is depicted above. The crew has a breeches buoy drill running, and they are apparently giving tours of the station as evidenced by the large crowd on the lookout and around the station. This station is an 1875 type drawn by Francis Chandler. This design is characterized by the heavy supports under the eaves and in the gables, and by the lookout platform and widow's walk on top of the boathouse. (Courtesy Michigan Maritime Museum.)

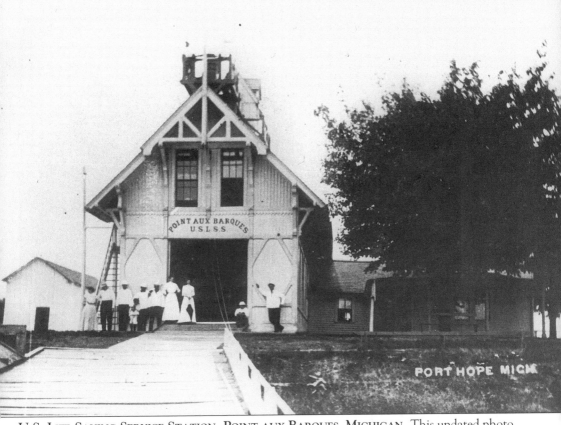

U.S. LIFE-SAVING SERVICE STATION, POINT AUX BARQUES, MICHIGAN. This undated photo shows the front of the Point aux Barques Station, also known as Port Hope. This photo shows the 1875 type station, with few alterations from its original design. Tragically, on April 23, 1879, the whole Point aux Barques crew, with the exception of Keeper Jerome Kiah, was lost attempting to rescue the crew of the *J.H. Magruder*. Ironically, the *Magruder* managed to save herself and get to a safe anchor. Kiah received the Gold Life-Saving medal, the highest honor awarded by the USLSS. He went on to become the long-time district superintendent for Lakes Huron and Superior. (Courtesy Michigan Maritime Museum.)

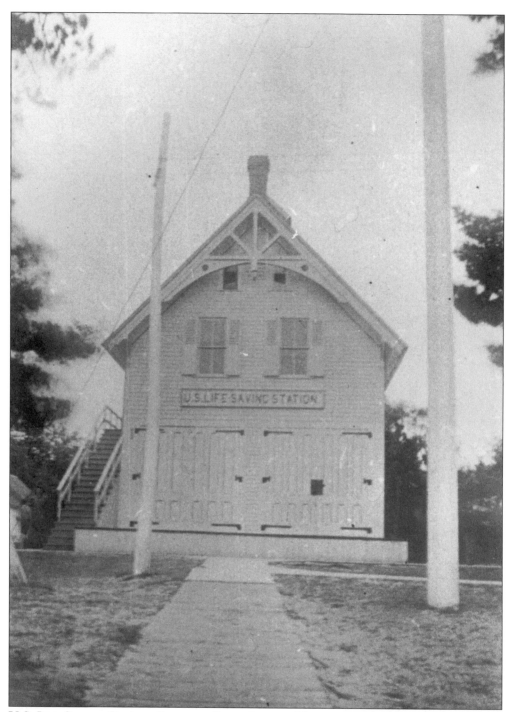

U.S. LIFE-SAVING SERVICE STATION, PORT AUSTIN, MICHIGAN. Also known as Grindstone City, the Port Austin Station is a fine example of J. Lake Parkinson's 1879 type. Pictured here in 1907, the Port Austin Station was completed in 1881. This postcard was used to announce the fact that the Culhanes were throwing a Pedro (card game) party. (Courtesy Michigan Maritime Museum.)

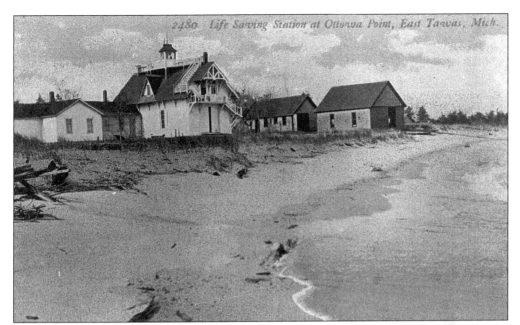

U.S. LIFE-SAVING SERVICE STATION, EAST TAWAS, MICHIGAN. The Tawas Station is another 1875 type design, and was originally known as Ottawa Point. The 1875 design is predominant on Michigan's Lake Huron side. Shown here is the complex exterior stairway leading up to the lookout. None of the 1875 stations on the Lakes had similar stairs. (Courtesy Michigan Maritime Museum.)

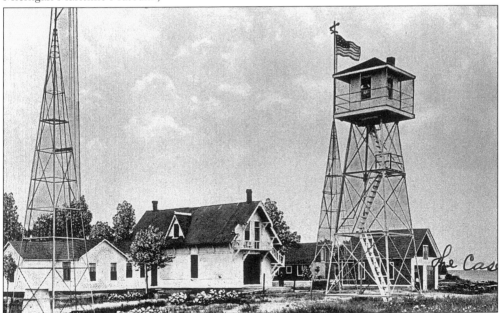

U.S. COAST GUARD STATION, EAST TAWAS, MICHIGAN. After a number of years, the Coast Guard did away with the complex staircase leading to the lookout tower at Tawas Point. The lookout tower was removed and a new one constructed on the beach. This station still stands and was in use into the 1980s, before the construction of the new facility. (Courtesy Michigan Maritime Museum.)

U.S. COAST GUARD, EAST TAWAS MICHIGAN. Pictured above is a quiet anchorage in for work on the lifeboat. Shown here is the station's work dingy and motorized surfboat. (Courtesy Michigan Maritime Museum.)

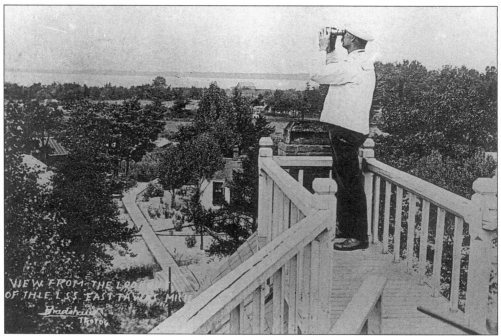

U.S. LIFE-SAVING SERVICE, EAST TAWAS, MICHIGAN. A surfman keeps the day watch at Tawas Point. A busy port, this station kept watch over Lake Huron in the direction the surfman is looking, as well as over Tawas Bay shown in the picture. (Courtesy Michigan Maritime Museum.)

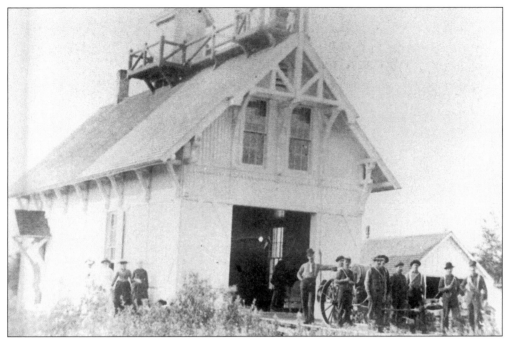

U.S. LIFE-SAVING STATION AND CREW, STURGEON POINT, MICHIGAN. Identical to Tawas except for the stairway, the Sturgeon Point Station is an 1875 type completed in 1876. Located just north of Harrisville next to the Sturgeon Point Lighthouse, the station was in operation into the 1940s. This early photo of Sturgeon Point shows visitors and the crew posing with the beach cart. (Alcona Historical Society.)

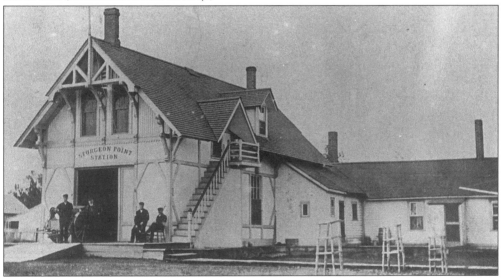

U.S. LIFE-SAVING STATION, STURGEON POINT, MICHIGAN. The Sturgeon Point crew also removed their lookout and built one on the beach about 1910. Here the crew pauses from their work for a photo in the front of the station. Drainage of water was a constant problem in this low swampy site, and the keeper often noted in his daily log entries that the practice grounds were wet. They also replaced several chimneys at Sturgeon Point, citing crumbling unsafe conditions of the current chimneys as the reason for replacement. (Alcona Historical Society.)

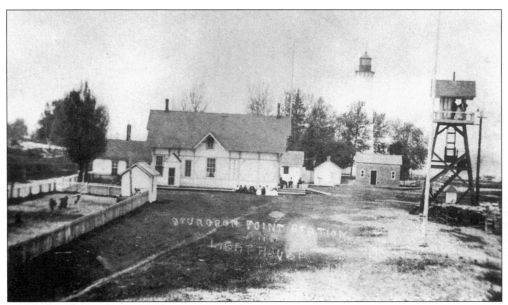

U.S. LIFE-SAVING SERVICE STATION, STURGEON POINT, MICHIGAN. This photo, c. 1910–15, clearly shows the Sturgeon Point Lighthouse in the background. There are a number of visitors sitting outside the station on its walkways. There are also two people in the lookout tower in the right of the picture. At this installation, the two branches of government service often switched jobs. Perley Silverthorn was the lighthouse keeper until he took on the duties of keeper for the USLSS station when it opened in 1876. At least one other surfman went on to become the keeper of the lighthouse. (Alcona Historical Society.)

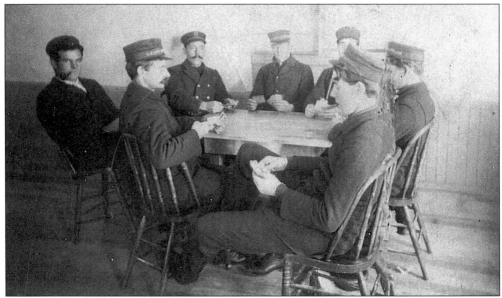

U.S. LIFE-SAVING SERVICE CREW, STURGEON POINT, MICHIGAN. It was not all work for the crew members of the USLSS. Here the Sturgeon Point crew takes time out for a card game in the station. Saturday was a day of cleanup around the station. In 1898, the keeper purchased a "Wedgeway 14-inch cut" lawnmower for cutting the grass at the station. Grounds at all stations were always kept in immaculate condition. (Alcona Historical Society.)

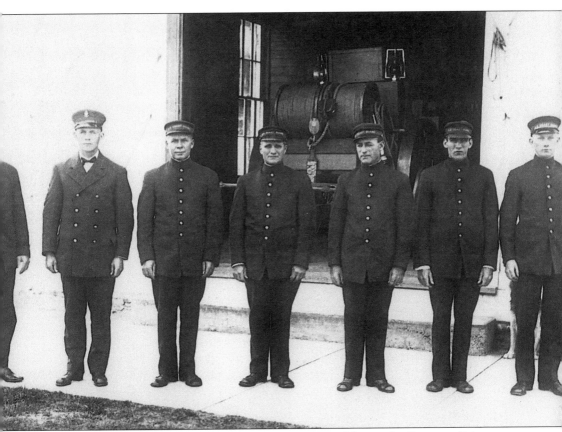

U.S. Coast Guard Crew, Sturgeon Point, Michigan. Here is the Sturgeon Point crew looking sharp in their dress uniforms, *c.* 1917. Pictured with them is one of their neighbors at the Point, a crewman for the U.S. Lighthouse Service standing to the left of the keeper. (Alcona Historical Society.)

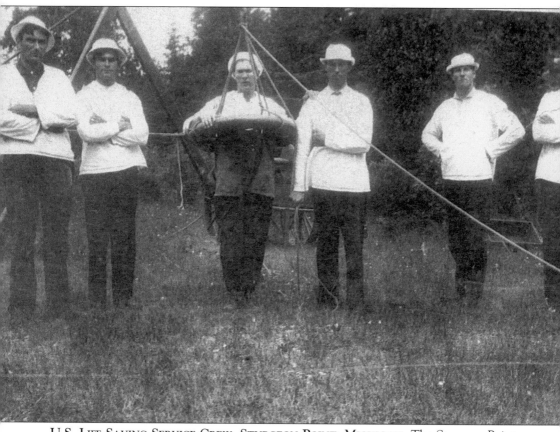

U.S. Life-Saving Service Crew, Sturgeon Point, Michigan. The Sturgeon Point crew pauses from their breeches buoy drill. The beach cart can be seen behind the man wearing the breeches buoy. The activities of the USLSS crewmen were a common topic of paintings and popular literature. Winslow Homer painted them, and tales of their rescues appeared in many magazines. (Alcona Historical Society.)

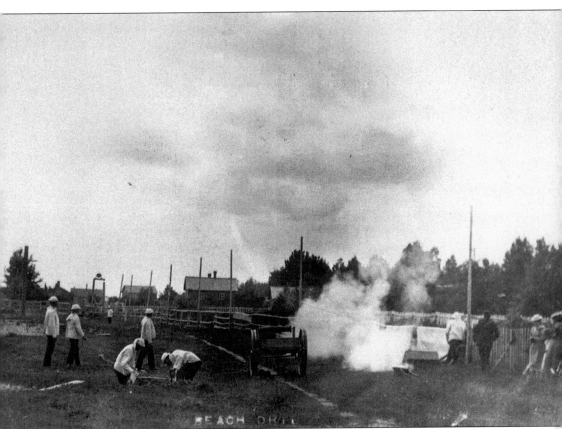

U.S. Life-Saving Service Crew, Sturgeon Point, Michigan. Firing the Lyle gun, this photo shows the messenger and line in the air. Eight crewmen are visible in the shot, and the messenger is above the fourth from left. The keeper is to the right near the two well-dressed women. (Courtesy Alcona Historical Society.)

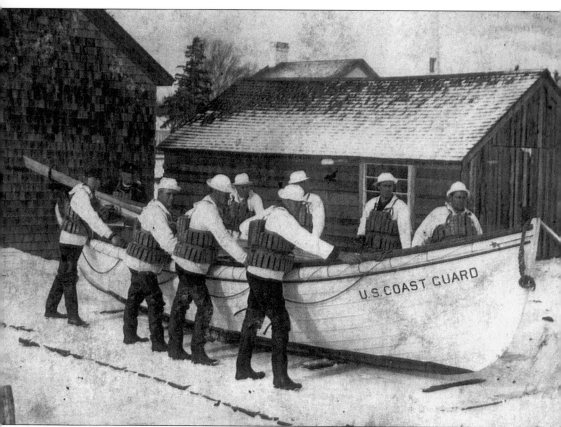

U.S. Coast Guard Crew, Sturgeon Point, Michigan. A separate boathouse was added to the station in later years, and this shot shows the crew with the surfboat in front of the new boathouse on a chilly day. Near the end of his career on Thursday, May 18, 1915, Keeper James Henderson made the following entry in his log: "Practiced with surfboat. Went to Harrisville with surfboat for Government Supplies. From Grand Haven Mich. 2 boxes hardware; 3 boxes paint; 1 box soap; 1 box glass; 1bbl glassware. . ." In all, keepers had about five hundred items they were to keep track of at the stations. (Courtesy Alcona Historical Society.)

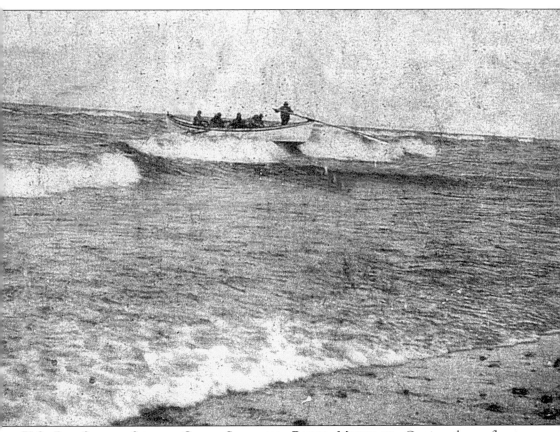

U.S. Life-Saving Service Crew, Sturgeon Point, Michigan. Getting the surfboat through the breakers was no easy task, but the Sturgeon Point crew makes it look easy. Only under the worst conditions were the crews of the USLSS unable to launch a boat. This launch is under relatively calm conditions. (Courtesy Alcona Historical Society.)

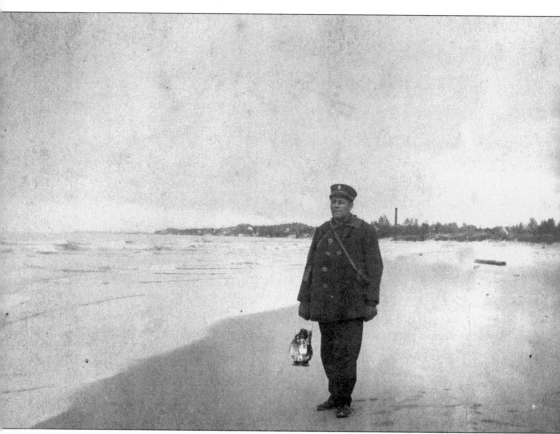

U.S. Life-Saving Service Crew, Sturgeon Point, Michigan. Here is surfman Claude Burrows on beach patrol. The USLSS considered beach patrol its most vital duty. Burrows carries a lantern, a bag of flares, and a patrol clock and punch key. The patrol clock and punch key system made sure that crewmen completed their patrols. At the far end of his patrol, he used a key to punch his clock and start the return trip. Patrols varied from 4 to 7 miles. (Courtesy Alcona Historical Society.)

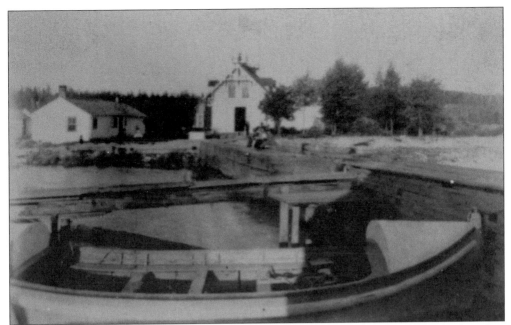

U.S. LIFE-SAVING SERVICE STATION, THUNDER BAY ISLAND, MICHIGAN. Completed in 1875–76, the Thunder Bay Island Station is a sister to Tawas and Sturgeon Point. Access to this station was by boat, with the closest large port being Alpena, Michigan. Prior to the introduction of motors in surfboats and lifeboats, the crews rowed or sailed back and forth from the mainland. (Courtesy Michigan Maritime Museum.)

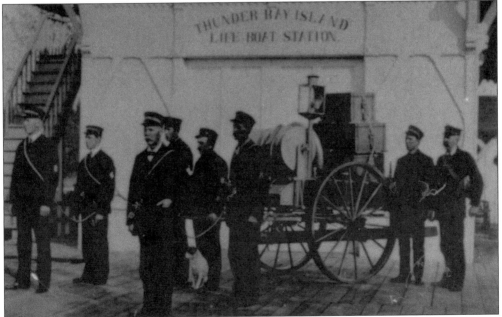

U.S. LIFE-SAVING SERVICE CREW, THUNDER BAY ISLAND, MICHIGAN. Here is a photo of the Thunder Bay Island Crew. This photo clearly shows the lantern kept on the beach cart for night rescues as well as the coils of hawser for the breeches buoy drill. (Courtesy Michigan Maritime Museum.)

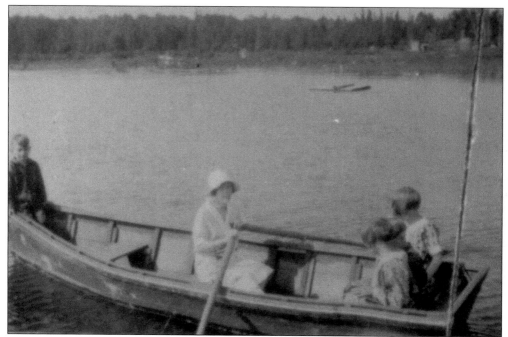

U.S. Coast Guard, Thunder Bay Island, Michigan. Captain E.G. Richardson served at numerous stations throughout the Lakes including Thunder Bay Island and Hammonds Bay. This 1927 photo features his wife and children. The photographs collected by his son, the late Captain Ted Richardson, seated at the bow of the boat, are now housed at the Michigan Maritime Museum and make historical work, such as this book, possible. (Courtesy Michigan Maritime Museum.)

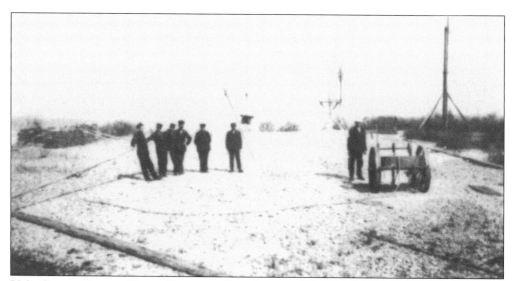

U.S. Coast Guard Crew, Thunder Bay Island, Michigan. Here is a shot of Captain E.G. Richardson in action with his crew in 1927. (Courtesy Michigan Maritime Museum.)

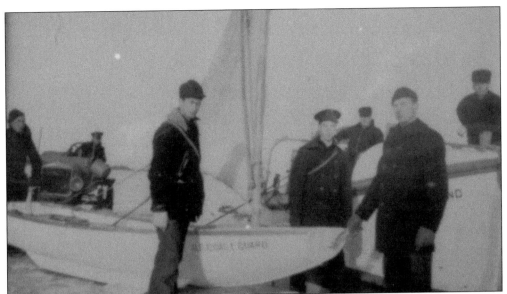

U.S. COAST GUARD CREW, THUNDER BAY ISLAND, MICHIGAN. Here are the Thunder Bay Island Coast Guardsmen dressed for chilly duty. This photo features the motor lifeboat as well as a small, fast Coast Guard sailboat. (Courtesy Michigan Maritime Museum.)

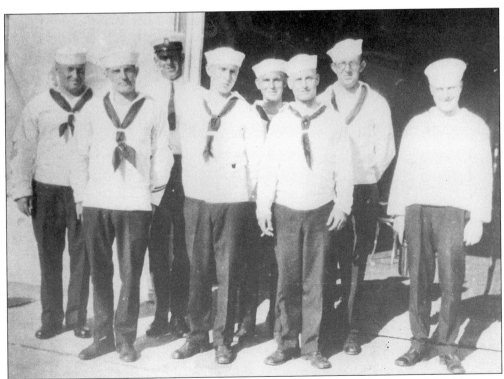

U.S. COAST GUARD CREW, THUNDER BAY ISLAND, MICHIGAN. Uniforms of the life-savers changed over the years. This photo of the Thunder Bay Island crew features the more typical naval type of the USCG. (Courtesy Michigan Maritime Museum.)

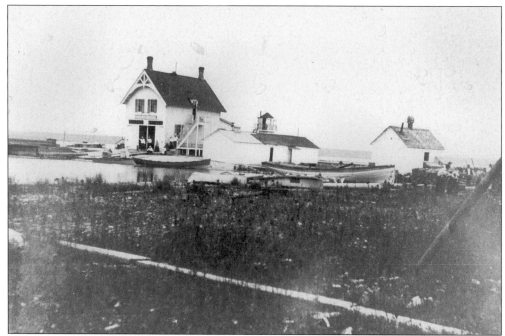

U.S. Life-Saving Service Station, Middle Island, Michigan. Middle Island was another example of Parkinson's 1879 type station. This shot shows a busy station with numerous boats and visitors on the grounds. (Courtesy Michigan Maritime Museum.)

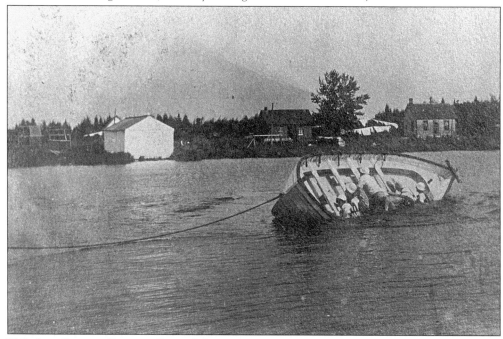

U.S. Life-Saving Service Crew, Middle Island, Michigan. "Everything O.K. fine time," is what this postcard of July 16, 1906 says. The postcard features a fully submerged Middle Island USLSS crew during boat practice. Middle Island is in Lake Huron, just north of Alpena. (Courtesy Michigan Maritime Museum.)

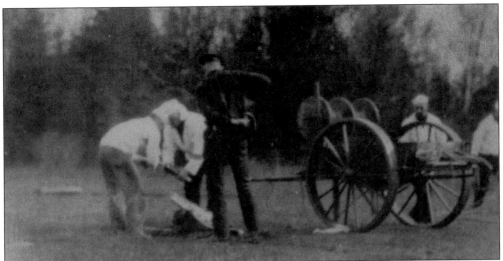

U.S. COAST GUARD CREW, HAMMOND BAY, MICHIGAN. Another 1875 type station, the Hammond Bay or 40 Mile Point Station (not pictured) is used today by the U.S. Fish and Wildlife Service for aquatic research. This photo shows what is believed to be the Hammond Bay crew loading the Lyle gun. The messenger weighed 18 pounds, and after successful rescues, the crews painted the details of the event on the messenger and placed them in the station for display. (Courtesy Michigan Maritime Museum.)

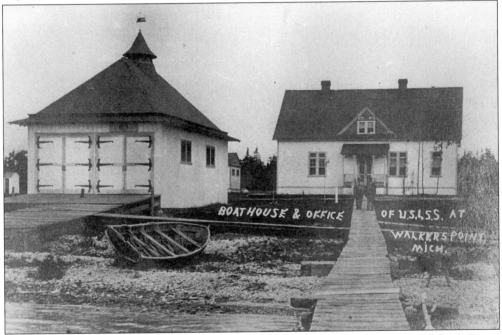

U.S. LIFE-SAVING STATION, BOIS BLANC ISLAND, MICHIGAN. Also known as Walker's Point, this station was built in 1891, and is a Marquette type designed by Albert Bibb. The Marquette type is a gabled building with triangular shaped dormer windows and small porches with turned columns. The Marquette type stations were typically accompanied by boathouses similar to this one. Bois Blanc Island is in the Straights of Mackinaw south and east of Mackinac Island. (Courtesy Michigan Maritime Museum.)

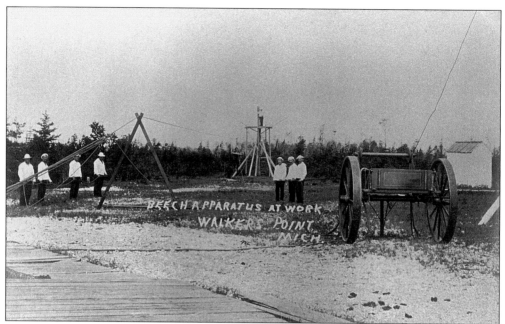

U.S. LIFE-SAVING STATION, BOIS BLANC ISLAND, MICHIGAN. Here are the eight men of the Bois Blanc Island crew drilling with the breeches buoy. The buoy is halfway between the crewman in the mast of the vessel and the men on "shore." Interestingly, there appears to be a civilian volunteer riding in it. (Courtesy Michigan Maritime Museum.)

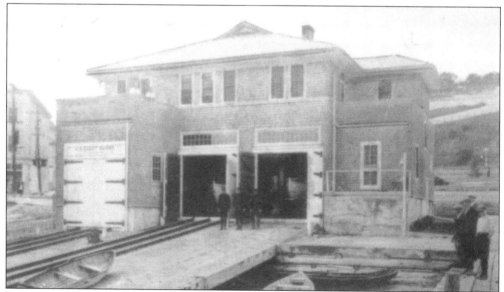

U.S. COAST GUARD STATION, MACKINAC ISLAND, MICHIGAN. Built in 1916, the Mackinac Island Station is a one-of-a-kind building designed by Victor Mendleheff. Today visitors to the Island recognize it as the Mackinac Island State Parks Commission Visitor Center. This handsome building is in the harbor at the base of Fort Mackinac. (Courtesy Michigan Maritime Museum.)

Three

LAKE SUPERIOR

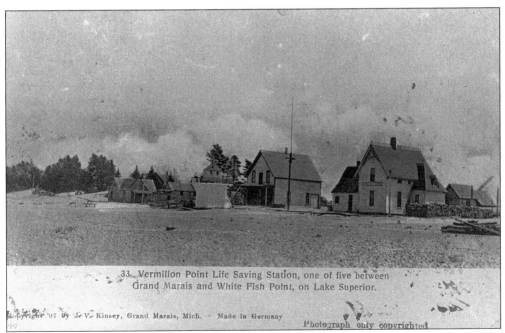

U.S. LIFE-SAVING SERVICE STATION, VERMILION, MICHIGAN. Built in 1876 along Lake Superior's southeastern shore, Vermilion is a Lake Superior type station designed by J. Lake Parkinson. Parkinson utilized the popular "stick" style of architecture for this station design characterized by the bracing in the gables. (Courtesy Michigan Maritime Museum.)

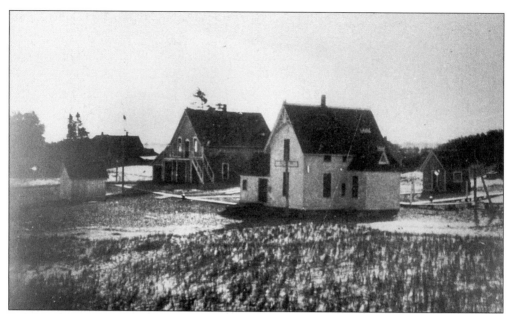

U.S. Life-Saving Service Station, Vermilion, Michigan. Here is a popular moonlight shot of the Vermilion Station. The Vermilion Station is still standing, but its future is rather precarious. Other Lake Superior stations like it, including Crisp's Point, Deer Park, and the Two Hearted River Station, disappeared years ago. (Author's Collection.)

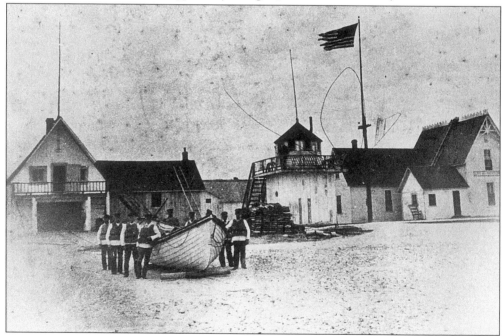

U.S. Life-Saving Service Station, Vermilion, Michigan. Here is a shot of the Vermilion crew with their surfboat. Notice the unusually shaped lookout tower. The watchtower had a chimney in it so that watchmen could keep warm during the very cold watches of early spring and late fall. The USLSS stipulated that while the stoves were allowed, they must be procured by the crews at their own expense. (Author's Collection.)

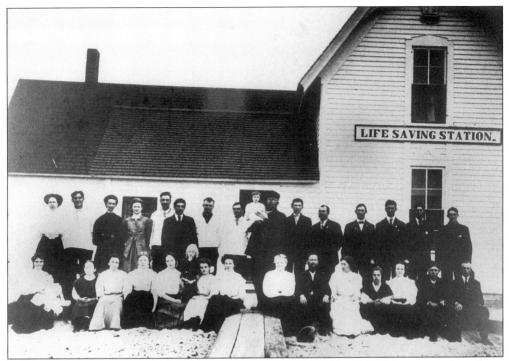

U.S. Life-Saving Service Station, Vermilion, Michigan. USLSS stations drew large crowds, and this Vermilion get-together is yet another example of their popularity. Apparently the large man in the center holding the child is Keeper James A. Carpenter. Lake keepers were tough, and Vermilion Captain Samuel Bernier once shot a crewman's dog after the surfman refused Berniers's order to tie it up. (Courtesy Lake Superior State University.)

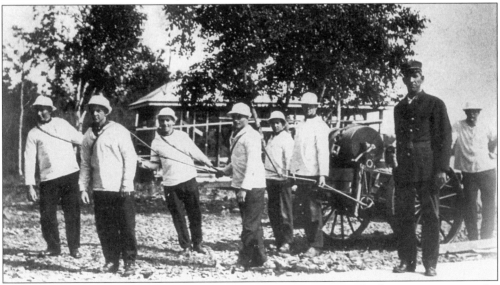

U.S. Life-Saving Service Station, Vermilion, Michigan. The best way to move the beach cart to the scene of a rescue is sheer manpower. Here the Vermilion crew poses in the harness, so to speak. Pulling the cart to the scene of rescue through the soft beach sand must have been a difficult task. (Courtesy Lake Superior State University.)

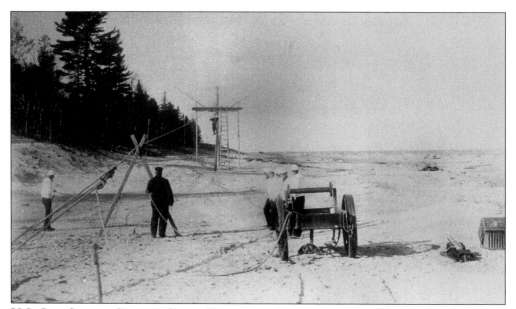

U.S. LIFE-SAVING SERVICE CREW, VERMILION, MICHIGAN. This is believed to be Keeper Carpenter drilling with his crew. The Vermilion Station and its crews managed to save 700 people in response to 51 vessel accidents between 1885 and 1914. The number one surfman at Vermilion for a number of years is reported to have been a Native American. In the summer, people traveled to Vermilion for berry picking, particularly during the Great Depression. It was also the site of one of Michigan's most successful cranberry farms. (Courtesy Lake Superior State University.)

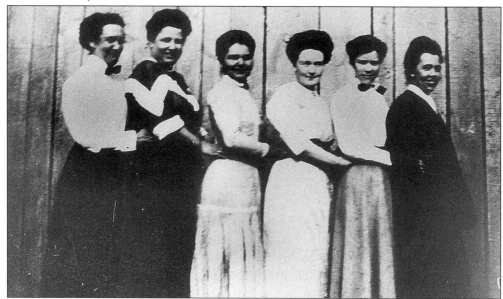

U.S. LIFE-SAVING SERVICE, VERMILION, MICHIGAN. Vermilion was a small, extremely isolated community. Here, as elsewhere on the Lakes, many of the men had wives and families living at the station with them. Picnics at nearby Betsey Lake and potluck suppers with dances at the station house were popular pastimes at Vermilion. (Courtesy Lake Superior State University.)

U.S. Life-Saving Service, Vermilion, Michigan. Vermilion may have been remote, but that did not stop these two women from having their portraits taken. At one point, Vermilion had enough children at the station to justify hiring a teacher. During the Coast Guard years at Vermilion and other Lake Superior stations, the Coast Guard sent a truck to town in the fall for one final load of supplies. After the snow started to fall, the families at Vermilion were mostly cut off from the rest of the world. Mail came in during the winter through the use of dogsled. (Courtesy Lake Superior State University.)

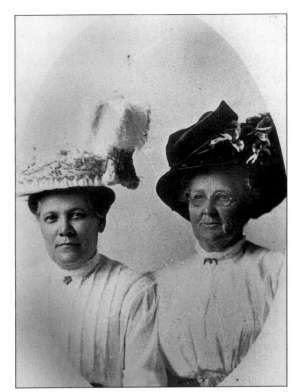

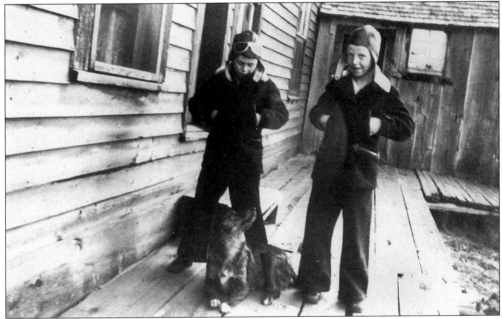

U.S. Coast Guard, Vermilion, Michigan. Before moving to the Munising Station in 1933 when it opened, Leland Parks (right) and his brother Dick lived with their parents at Vermilion. Brownie (center laying down) moved with them and was a constant companion. The boys were known around the station as the Cats and Jammer Kids, after a comic strip of the day. (Courtesy Dr. Leland Parks.)

U.S. COAST GUARD, VERMILION, MICHIGAN. Leta Parks is sitting on the beach with the members of another of Vermilion's families. Leta often passed the evenings reading western novels to her family. Due to the lack of a school and nearly impossible travel conditions of winter, the Parks family sent their boys off to school in the fall and did not see them until spring. (Courtesy Dr. Leland Parks.)

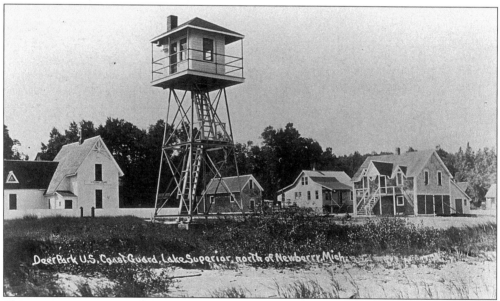

U.S. COAST GUARD, DEER PARK, MICHIGAN. Also known over the years as Sucker River and Muskallonge Lake, the Deer Park Station was built in 1876 in the same Lake Superior style as Vermilion. The records of the U.S. Life-Saving Service give impressive numbers for the remote facilities on the eastern end of Lake Superior. In all, the four easternmost stations saved 1,479 people from 1885 to 1915. If you wrecked in an area covered by the USLSS, your chances of surviving rose dramatically. (Courtesy Michigan Maritime Museum.)

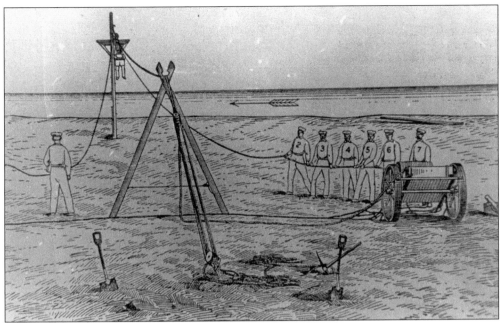

U.S. LIFE-SAVING SERVICE, BREECHES BUOY DRILL. The regulations of the USLSS were very explicit. Each drill was illustrated giving complete instructions for every single operation. This is an example of such illustrations from the Life-Saving Service. At this point in the drill, the keeper gave the command "haul ashore" and surfmen 2–7 pulled the breeches buoy to shore.

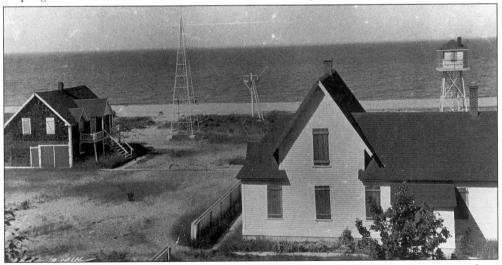

U.S. COAST GUARD, DEER PARK, MICHIGAN. The final days of a USLSS station are seen here as the Deer Park Station sits abandoned with its windows boarded up. This was once the command station of the famous Captain Henry Cleary. A typical rescue for Cleary's well-trained men involved the rescue of the crew of the *Starrucca* on November 15, 1887. Cleary and his men rowed 12 miles in the late afternoon to the site where the *Starrucca* was in distress. At that time, the captain of the vessel decided to hang on a little longer. Cleary took his men to shore to watch for further developments. As the conditions worsened, the *Starrucca* signaled for Cleary and the USLSS to come again to the rescue. The life-savers made three trips in the dark and snow to remove the crew. (Courtesy Michigan Maritime Museum.)

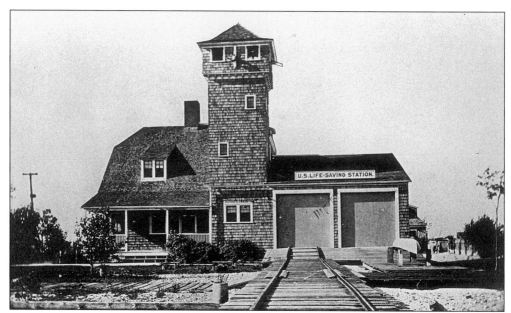

U.S. LIFE-SAVING STATION, GRAND MARAIS, MICHIGAN. Built in 1900, the Grand Marais Station is a Duluth type designed by George R. Tolman. This design features a tall, attached lookout with an outer covering of shingles. A surfman is visible in the right window in the top of the lookout tower. (Courtesy Michigan Historical Center.)

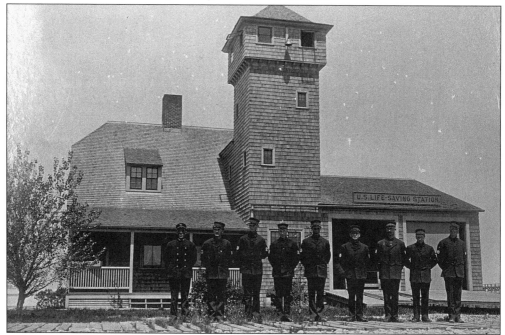

U.S. LIFE-SAVING STATION, GRAND MARAIS, MICHIGAN. The keeper is on the far left of this alert group of surfmen. The alarm bell is clearly visible between the windows of the watchtower. All stations had similar alarm bells, which were used to alert crews in the event of a disaster. On at least one occasion on the Lakes, the bell was used to alert surfmen to the fact that the station was on fire. (Courtesy Michigan Historical Center.)

120

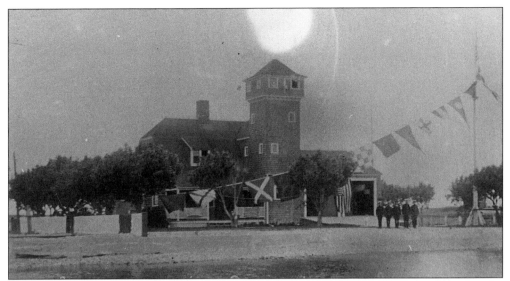

U.S. COAST GUARD, GRAND MARAIS, MICHIGAN. Crews celebrated Independence Day by displaying the colorful signal flags at the station. Many stations celebrated with competitions between neighboring crews to see who could perform the various drills the fastest and who could use the heaving stick to throw a line the farthest. R.M. Small, the keeper at Crisp Point, recorded that one of his surfmen in 1890 could heave the stick 102 feet. (Courtesy Michigan Maritime Museum.)

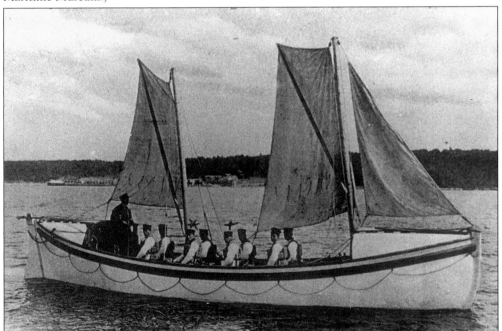

U.S. LIFE-SAVING SERVICE, GRAND MARAIS, MICHIGAN. This postcard features Captain Benjamin Trudell and his crew of Grand Marais life-savers. This crew is rigged for sail in their motorized lifeboat. Boat practice was repetitive in the hopes that the handling of the boat in rescue situations would become second-nature for the men of the USLSS. (Courtesy Michigan Maritime Museum.)

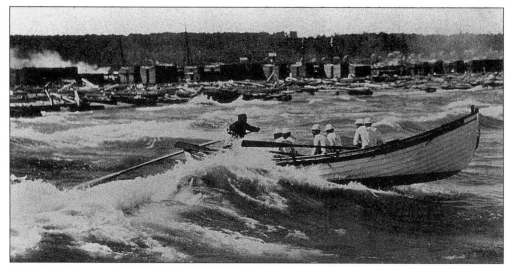

U.S. LIFE-SAVING SERVICE, GRAND MARAIS, MICHIGAN. This is a famous shot of Captain Trudell and his Grand Marais crew rowing their surfboat through the Lake Superior breakers. It was during times like this that all the long hours of boat practice paid off for the crews of the USLSS. Crews often rowed 10 miles or more in rough conditions during rescues. (Courtesy Michigan Historical Center.)

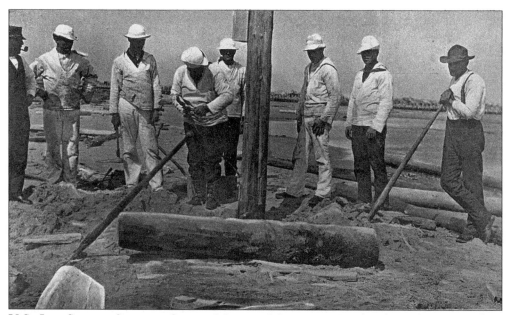

U.S. LIFE-SAVING SERVICE, GRAND MARAIS, MICHIGAN. Besides the ordinary mundane chores the life-saver contended with, there were government projects such as connecting telephone lines. The USLSS was quick to adopt technological advances aiding communications. (Courtesy Michigan Historical Center.)

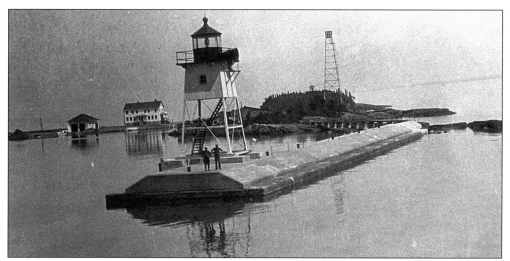

U.S. COAST GUARD, GRAND MARAIS, MICHIGAN. Pictured here are quiet times for the USCG at Grand Marais. This photo shows the harbor light with the station and boathouse in the background. While calm and beautiful in this photo, Lake Superior has a mean streak and often tested the abilities of the USLSS. Perhaps this is even the toughest of the Lakes, and many famous keepers cut their teeth here. (Courtesy Michigan Historical Center.)

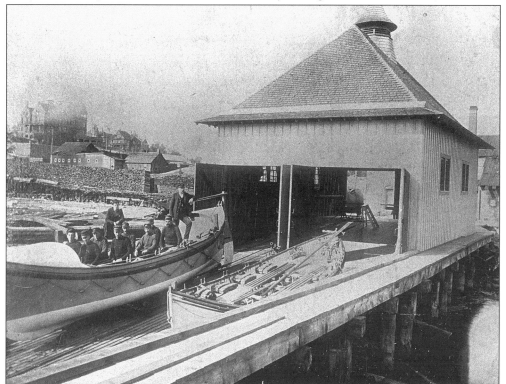

U.S. LIFE-SAVING SERVICE AND CREW, MARQUETTE, MICHIGAN. Albert Bibb drew the plans for this station in the late 1890s. Upon its construction in 1890, the Marquette Station became the first Marquette type station built on the Lakes. Shown here are both of the station's boats and its nine-man crew sitting in the motor lifeboat. (Courtesy Michigan Historical Center.)

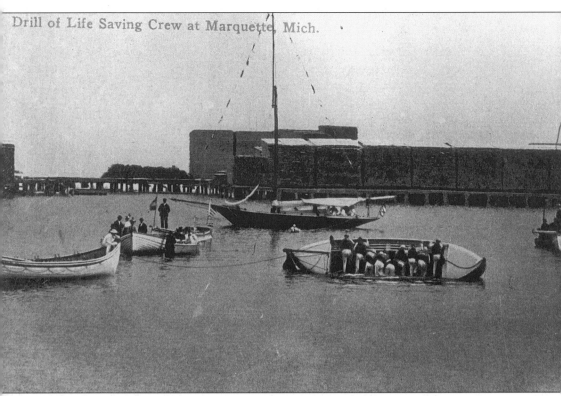

Drill of Life Saving Crew at Marquette, Mich.

U.S. LIFE-SAVING SERVICE AND CREW, MARQUETTE, MICHIGAN. This photo features the Marquette USLSS crew. The keeper may be Henry Cleary, a very well known Life-Saving Service keeper. The USLSS often put Henry Cleary in charge of training life-saving crews in preparation for their duties at World's Fairs and Expositions. While famous for its iron ore, notice the lumber on the docks awaiting shipment out of Marquette. (Courtesy Michigan Maritime Museum.)

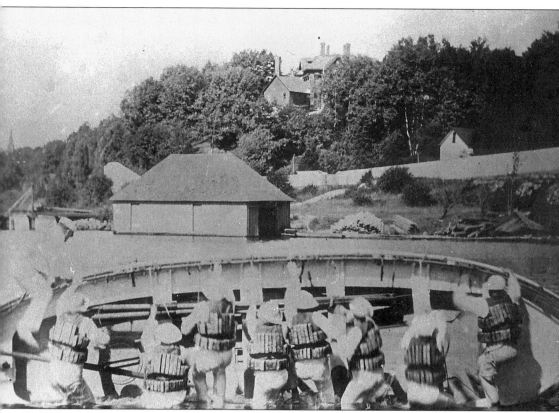

U.S. LIFE-SAVING SERVICE AND CREW, MARQUETTE, MICHIGAN. This photo shows the crew pulling the boat over or capsizing it during a drill. The keeper is seen in the rear keeping ahead of the boat's roll. Keeper Henry Cleary could complete the whole drill getting only his ankles wet. Notice that gear is stowed so as not to come loose during this drill. (Courtesy National Park Service.)

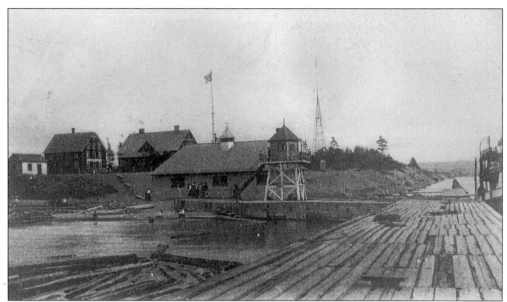

U.S. LIFE-SAVING SERVICE STATION, HOUGHTON MICHIGAN. Built in 1902, the Houghton Station was also a Marquette type design. Pictured in this postcard is the boathouse and lookout tower. The station itself is visible just behind and to the rear of the boathouse on top of the hill. (Courtesy Michigan Maritime Museum.)

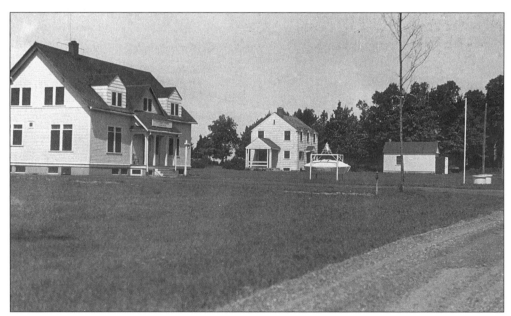

U.S. COAT GUARD STATION, HOUGHTON, MICHIGAN. Also known as Portage and Ship Canal, the Houghton Station is located on Lake Superior's great shortcut—the ship canal that cuts through the Keweenaw Peninsula. This photo clearly shows the retired life car on display outside the station. (Courtesy Michigan Historical Center.)

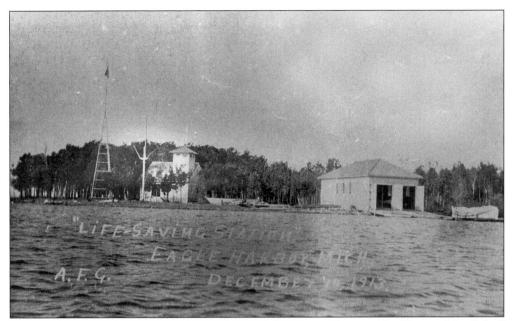

U.S. LIFE-SAVING STATION, EAGLE HARBOR, MICHIGAN. Designed by Victory Mendleheff around 1910 and built in 1912, the Eagle Harbor Station is the only Lorain type station in Michigan. This photo shows the boathouse, signal tower, and wreck pole for the breeches buoy drill. While the photo is dated December 1913, the leaves on the trees and lack of ice and snow clearly indicate that this is a summer photo. (Courtesy Michigan Maritime Museum.)

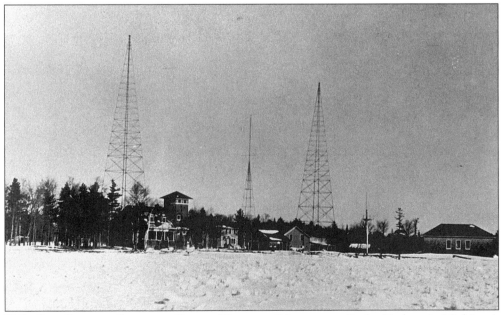

U.S. LIFE-SAVING STATION, EAGLE HARBOR, MICHIGAN. Eagle Harbor is Michigan's northernmost life-saving station. This photo provides viewers with some idea of what it would have been like there in December. Many times, keepers and crews on Lake Superior opened their stations long before the ice and snow had left the Lake. (Courtesy Michigan Historical Center.)

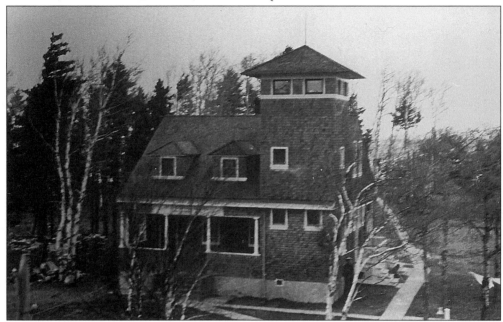

U.S. LIFE-SAVING STATION, EAGLE HARBOR, MICHIGAN. This is a better photo of the Eagle Harbor's Lorain type station. The lookout tower was integrated into the station house as a whole. During the cold months this was quite an advantage. (Courtesy Michigan Historical Center.)

SUGGESTED READING

Bennett, Commander Robert F., USCG *Surfboats, Rockets, and Caronnades*.
 Washington: Government Printing Office, 1977.
Bibb, A.B. "The Life-Saving Service on the Great Lakes." *Frank Leslie's Popular
 Monthly*, vol. 13 (April 1882), p. 386–98.
Noble, Dennis L. *A Legacy: The United States Life Saving Service*. Washington: United States
 Coast Guard, 1976.
———. *That Others Might Live: The U.S. Life Saving Service, 1878–1915*.
 Annapolis: The Naval Institute Press, 1994.
Peterson, William D. *Storm Warriors: The United States Life-Saving Service in American
 Culture, 1870–1915*. Ph.D. dissertation, Bowling Green State University, 1998.
Shanks, Ralph and Wick York. *The U.S. Life-Saving Service: Heroes, Rescues and Architecture of the Early Coast
 Guard*. Petaluma: Costano Books, 1996.
Stonehouse, Frederick. *Wreck Ashore: The United States Life-Saving Service on the Great Lakes*.Duluth: Lake Superior
 Port Cities, 1994.
United States Life Saving Service, *Annual Report of the U.S. Life-Saving Service*. Washington:
 Government Printing Office, 1876.
United States Coast Guard. *Annual Report of The United States Coast Guard*. Washington:
 Government Printing Office, 1915.

*For further information on the U.S. Life-Saving Service, contact the United States Life-Saving
Service Heritage Association, P.O. Box 75, Caledonia, Michigan 49316–0075*